IN AND AROUND BISHOP'S CLEEVE

THROUGH TIME

A Second Selection

David Aldred *&* Tim Curr

AMBERLEY PUBLISHING

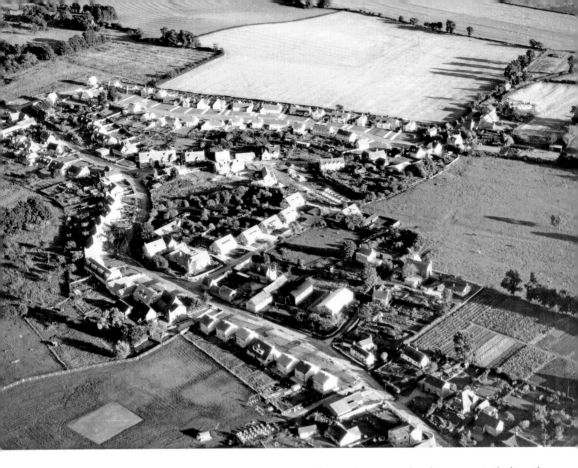

Gotherington from the air looking southeast in 1965 shows the recent developments including the extension to The Lawns, before the school was built, Ashmead Drive and infilling along the north side of Malleson Road. Many farm buildings are still standing and the horticultural use of what became Lawrence's Meadow can be clearly seen; the cricket square has remained unchanged.

First published 2010

Amberley Publishing
Cirencester Road, Chalford,
Stroud, Gloucestershire, GL6 8PE

www.amberley-books.com

Copyright © David Aldred & Tim Curr, 2010

The right of David Aldred & Tim Curr to be identified as the Authors of this work has been asserted in accordance with the Copyrights, Designs and Patents Act 1988.

ISBN 978 1 84868 540 6

British Library Cataloguing in Publication Data.

A catalogue record for this book is available from the British Library.

Typeset in 9.5pt on 12pt Celeste.
Typesetting by Amberley Publishing.
Printed in the UK.

Introduction

Welcome to our second selection of 'then and now' photographs in and around Bishop's Cleeve. As we completed our first volume we realised we already had the basis for this second volume. Our central theme remains the same, as epitomised by the front cover, as we have again attempted to illustrate the ways in which the villages changed from small farming settlements to the busy communities of today. We have done this in certain ways; some similar to our first volume and others rather different.

Readers might recognise that some of the modern scenes also appeared in the first selection; for example Mill Parade in Bishop's Cleeve and the tram stop in Southam. This is because we have discovered further interesting old scenes. In other examples we have been able to add to the historic photographs in the first book and so, for example, we present here more photographs of Bert Long's Pecked Piece Farm in Pecked Lane and more views of Cleeve Common.

On the other hand we have developed some new approaches. One has been to relate groups of people and events to the modern scene; the chapel congregation of Gotherington in 1939; Bishop's Cleeve Carnival in 1937 and Woodmancote chapel's sale of work in the Old Village Hall in 1958. Another new idea has been to include two interesting old photographs on the same page, for example the tram stop on Cleeve Hill and Hales Farm in Gotherington. Then finally we have expanded our area by taking in the historic monument of Teddington Hands and some fascinating photographs of the building of the world-famous Bugatti Hill Climb at Prescott, which we hope will appeal to readers from a wider area than our own.

As we pointed out in the first volume, changes over the last century or so have taken place at different times in different places. On some pages there appears to be little change between the two scenes; Cleeveland's farmhouse in Station Road is one example and the Rising Sun Hotel

on Cleeve Hill another. Yet other changes have been significant; Bishop's Park along Stoke Road has completely disappeared, as has the view of Haymes in Southam. Major changes do not, however, have to have taken place many years ago to be significant; the photograph of Bishop's Cleeve's parish office shows this most clearly.

We have found as much interest and enjoyment in compiling this second volume as we did our first. We hope you, the reader, will also find much of interest and enjoyment whilst adding to your understanding of the history of this small area lying along the north western edge of the Cotswold Hills.

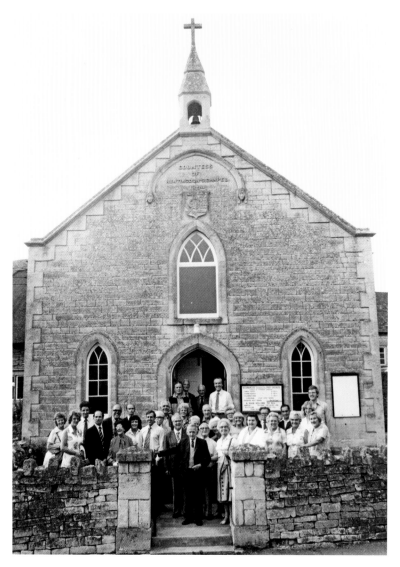

The congregation of Woodmancote Chapel are seen here celebrating with Tom Barrible his ninetieth birthday in March 1981. Tom was a remarkable local character and even at that age could be seen regularly walking to and from Cheltenham, more often than not whilst reading a book!

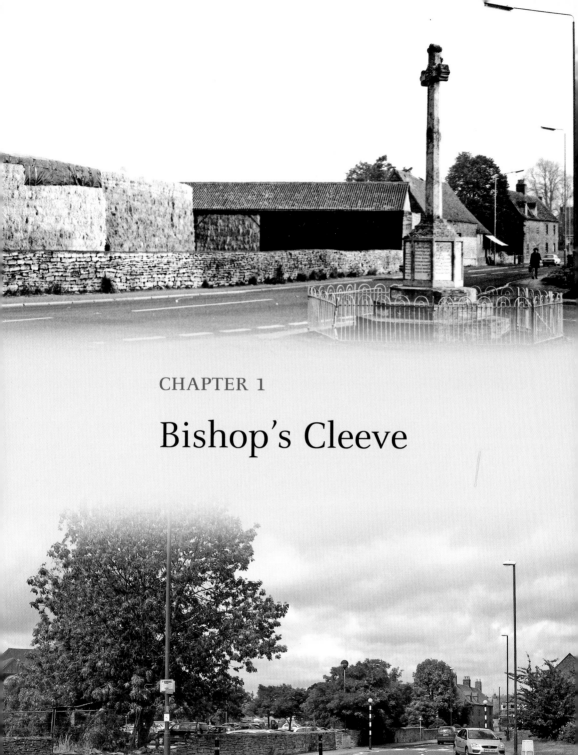

CHAPTER 1

Bishop's Cleeve

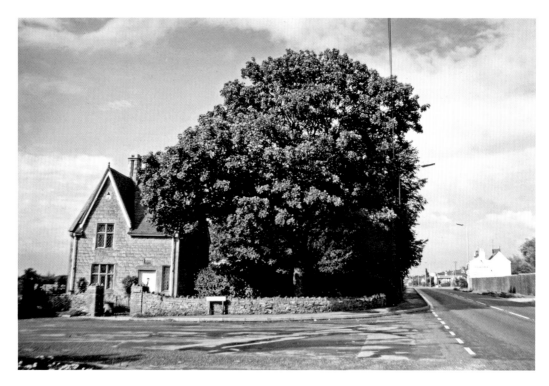

The Grange Lodge

This photograph from 1974 shows a country lodge at the end of Meadoway on the approach to Bishop's Cleeve from Cheltenham. It marked the start of the long drive to The Grange, built by Frederick Griffiths, a Cheltenham solicitor, in 1865. A vociferous local campaign saved The Grange from demolition in 1989, but the lodge was swept away when the entrance to Meadoway was reorganised. Today The Grange is approached from the bypass.

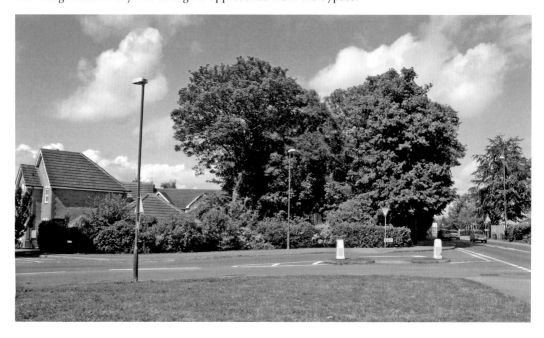

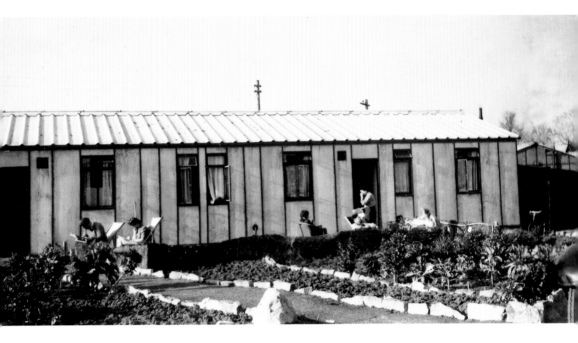

Bishop's Park

Here is a rare photograph of Bishop's Park, built in 1942 off Stoke Road to house workers from Smiths' factory, which had relocated to Bishop's Cleeve in 1939 at the outbreak of war. The Park was modelled on a Butlin's holiday camp. People lived here until the estate of permanent houses grew around Tobyfield Road in the village. By 1955 all the families had been rehoused and Bishop's Park closed. Today part of the site is occupied by Malvern View Business Park.

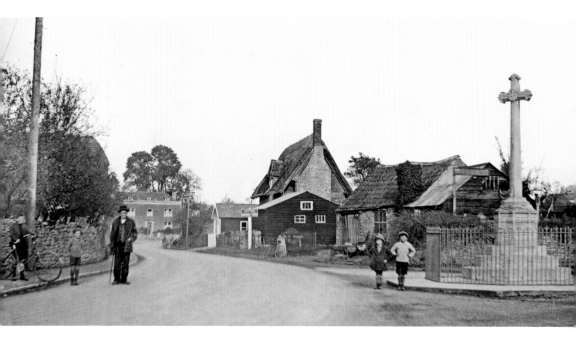

The War Memorial

We have many views of the original war memorial. All the buildings in the photograph of c1930 have been demolished, including Rose Villa, a rather splendid house facing down the road, which served as the home of the curate of Bishop's Cleeve for many years. The row of shops in the modern photograph have helped Church Road develop into the village's commercial centre.

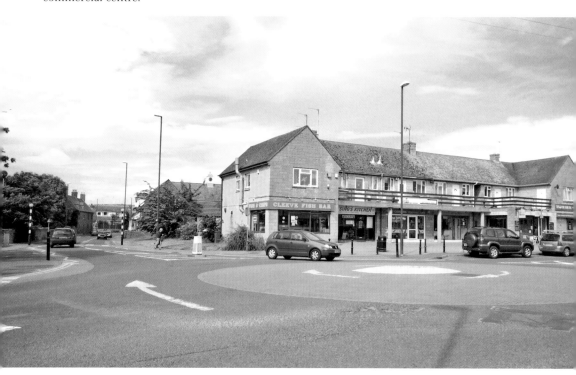

Home Farm

Our first volume showed Home Farm from the Evesham Road in 1905. The title page to this chapter shows the yard in 1977. Home to the Gilder family for many years, the top photograph shows the farm buildings immediately before demolition in 1994 to make way for Budgen's supermarket car park. With the arrival of Tesco four years later Budgen's could not compete. Today the car park is attached to Lidl's supermarket.

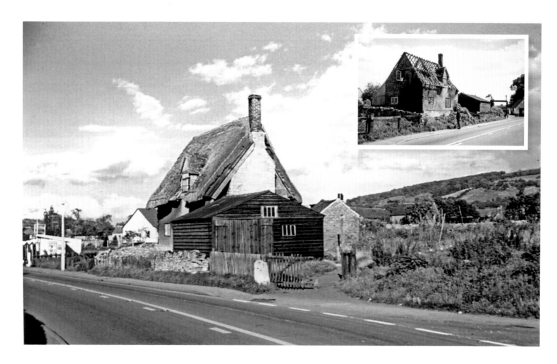

Evesham Road

Several photographs in our first volume were taken by the late Bill Potter of Meadoway, well-known nationally for his railway photographs. Here he has captured the blacksmith's house and forge in 1970 and their demolition a few years later. There had been a forge here for a hundred years but the development of the internal combustion engine lessened the need for horses. By 1939 George Wickes was working only three days a week.

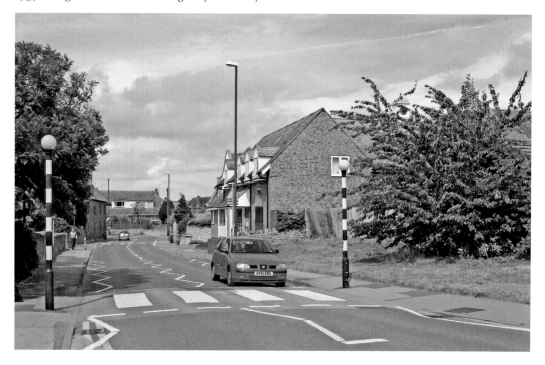

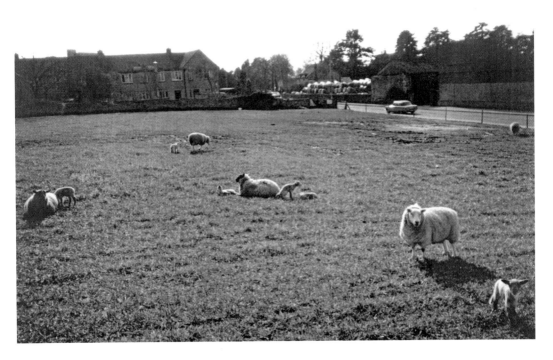

Gilders' Paddock

Next along the Evesham Road lay Gilders' Paddock, usually regarded as a vegetable patch, but here in 1988 laid out as pasture for sheep. Within a year the builders had moved in to create a complex of retirement houses, appropriately named after the paddock. A distant tree provides the point of reference.

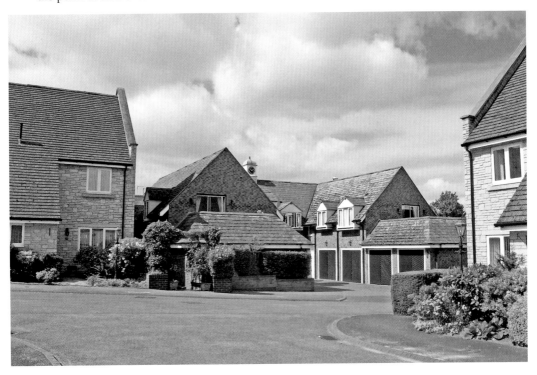

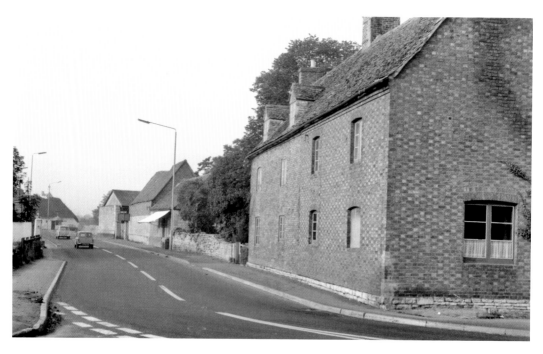

Gilders' Corner

Home Farm house remains unchanged although the farm buildings have disappeared, including Sid Gilder's popular butcher's shop, identified by its canopy. The sharp road corner here has caused traffic problems since the dawn of motoring. The first proposal to bypass this corner was made in 1926, but the village had to wait for another sixty five years! The upper view dates from the early 1970s.

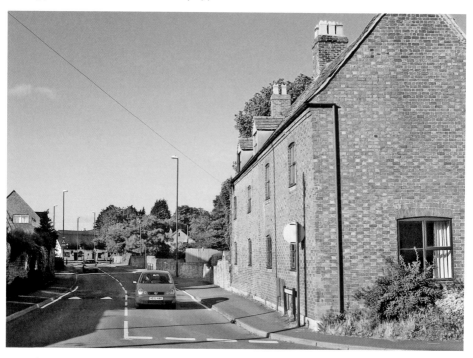

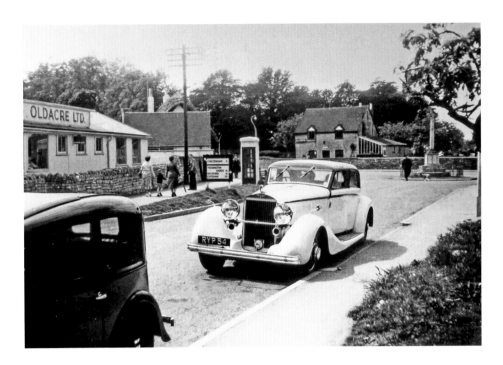

Oldacres

Our first volume charted the development of Church Road into the commercial centre of Bishop's Cleeve from the 1960s. The following pages provide further glimpses of this process. In the photograph of 1958 the car is the star – a pre-war Hispano-Suiza K6, worth more than a Rolls-Royce, but the background is also of interest showing the entry to Oldacres' mill and garage and the toilet block built onto the King's Head to celebrate the 1951 Festival of Britain. The telephone box, old post office and war memorial complete the scene.

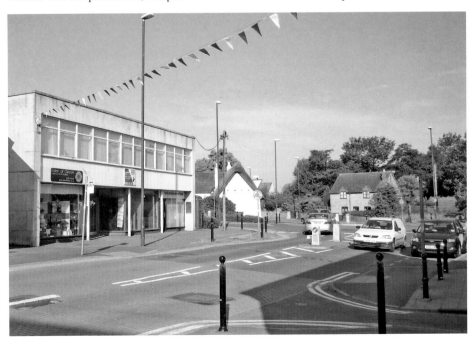

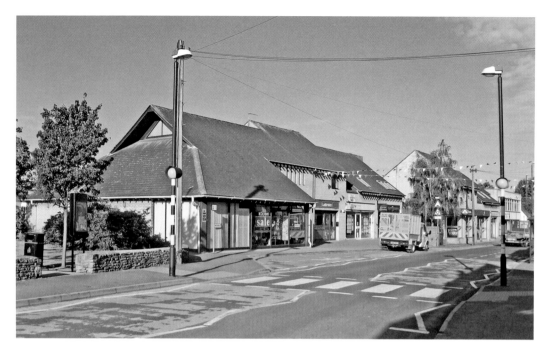

Mill Parade I

The sixteenth or seventeenth century timber-framed house, latterly known as the Cottage Loaf teashop, had housed the village fire engine until the war years. It was kept in the stone built attachment at the far end. So it was ironical that in 1976 the building was badly damaged by fire and subsequently demolished, allowing the development of Mill Parade shown here and opposite.

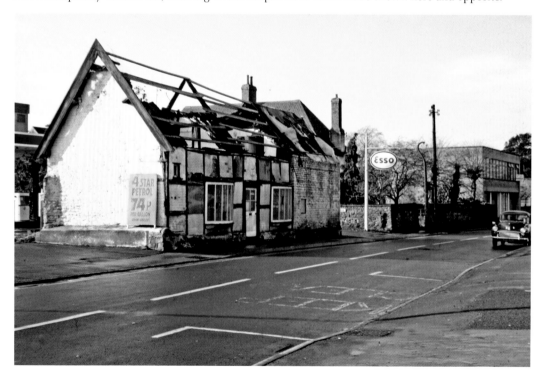

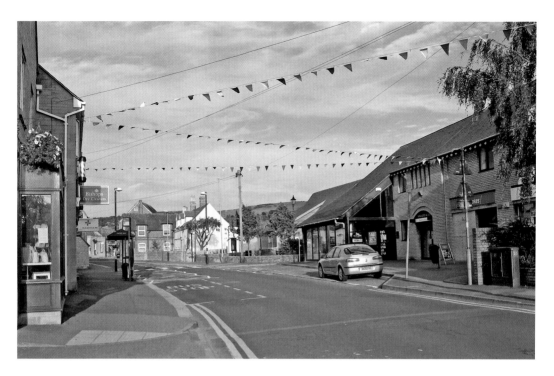

Mill Parade II

The lower view from August 1977 shows part of the extensive area along Church Road which was cleared, not only for Mill Parade, but also for the Tesco car park and a small garden. For a short time Oldacres' car showroom could be seen from Church Road. It later moved into that part of Mill Parade which Cat's Whiskers now occupies.

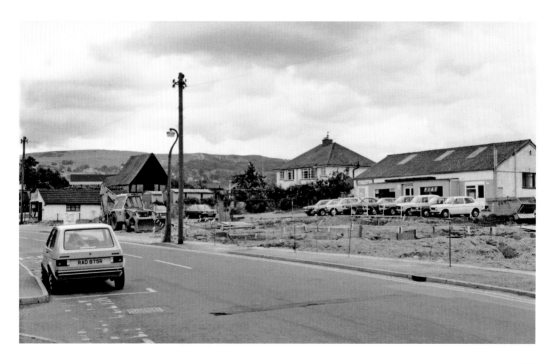

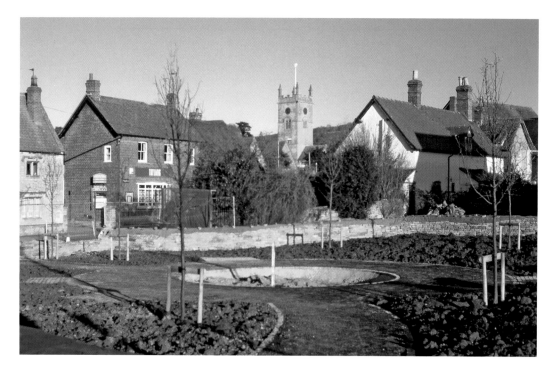

Church Road Garden

The clearances on the south side of Church Road gave an opportunity for creating a small oasis of calm where buildings once stood. The scene above was captured in 1999 after the garden had been laid out but before the water feature, using stone from the Forest of Dean, had been set up.

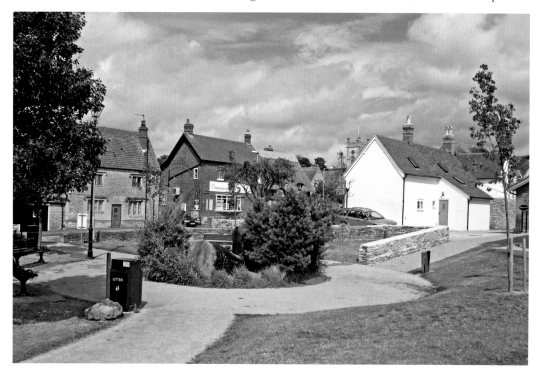

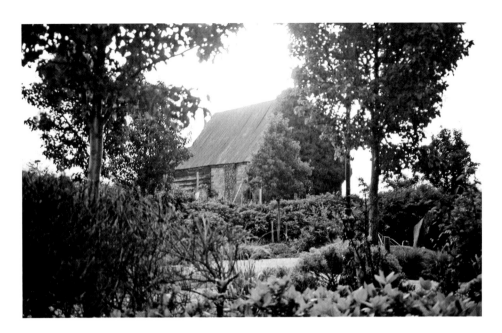

Parish Council Office

By 2007 the garden had matured and the greenery provided a picturesque frame for the last surviving remnant in the village centre of Bishop's Cleeve's farming past. When demolished, parts of the old barn were found to be over five hundred years old. Some timber work has been preserved as a feature in the parish council office, which replaced the barn shortly after the upper photograph was taken. Such has been the pace of change that a photograph taken only three years ago can now be considered as having historic interest.

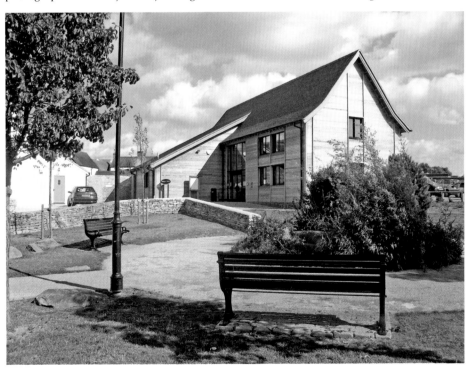

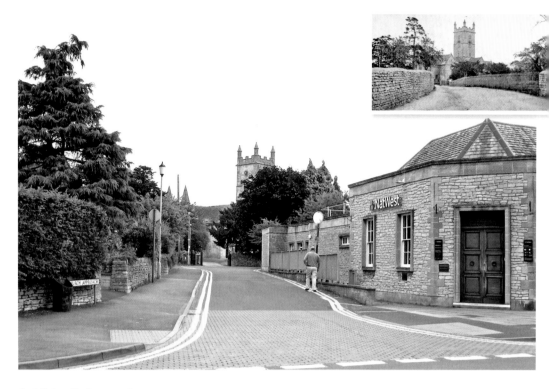

St Michael's Approach

The influence of the motor car on St Michael's approach can be seen in the upper photograph with the double yellow lines and turning circle. The inset shows how seventy years ago the church was approached between garden walls and until 1892 cottages had stood on the right. The lower photograph shows the choir returning to the church through the approach after the service at the war memorial in November 1965.

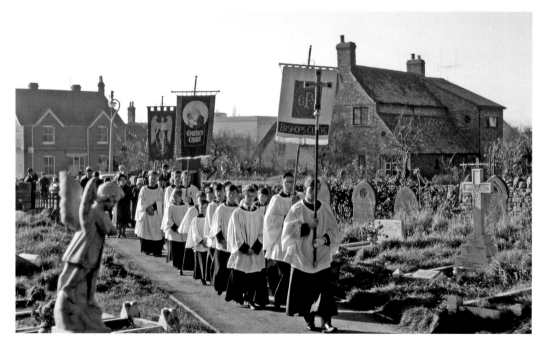

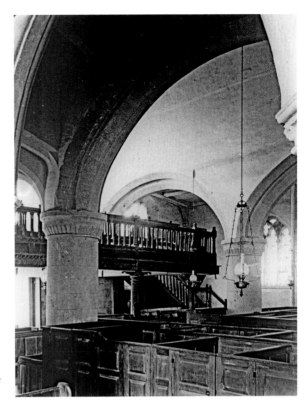

St Michael's Church

The top photograph dates from before 1892 when St Michael's Church was in such poor condition that an appeal which reached £5,000 was launched. The old box pews were swept away and the limewash was removed from the walls. Electricity replaced the oil lamps somewhat later but the old seventeenth-century musicians' gallery has survived. Today the church supports a lively worshipping community.

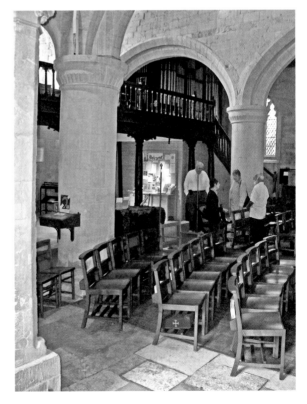

19

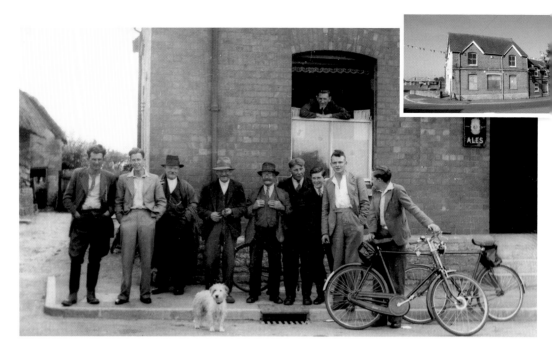

The Old Elm Tree

Opposite the church approach stands The Old Elm Tree. In the top picture the landlord Dick Chandler stands at the door behind an array of regulars sometime before the outbreak of war in 1939. The lower photograph records the first meeting of Bishop's Cleeve youth club with its members posing outside the building in 1960. Despite its present appearance, the building is still used by the youth of the village today, serving as the local headquarters for the Air Training Corps and the Army Cadet Force.

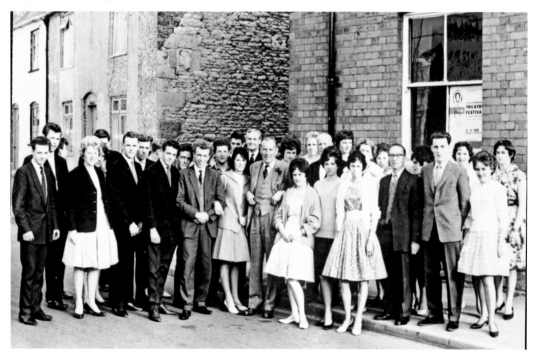

The Royal Oak

An earlier photograph of this scene appeared on the cover of our first volume. Little really had changed by the time of this pre-war snapshot of Church Road, when only the Royal Oak brought a commercial feel to this part of the road. The modern picture shows the changed nature of the road. Observant readers will note how two houses have been demolished for the car park entrance.

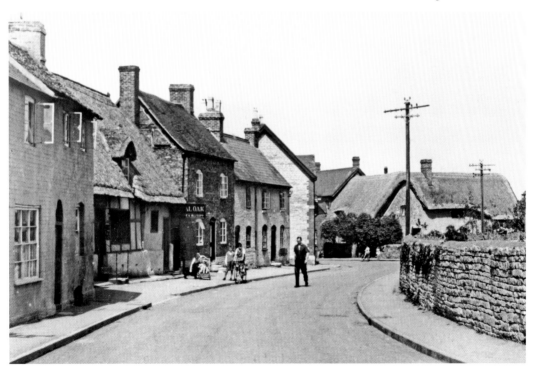

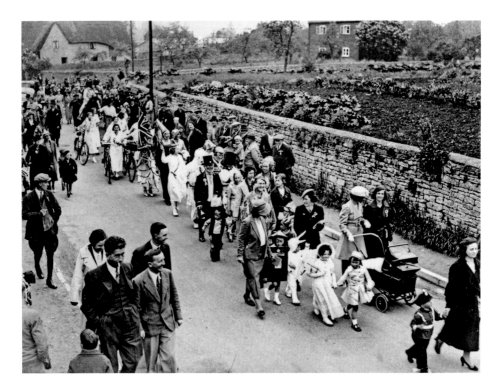

Village Celebrations in Church Road

People of Bishop's Cleeve have always enjoyed celebrating. Our historic photograph captures the fancy dress parade celebrating the Coronation of King George VI and Queen Elizabeth in 1937. The parade was on its way to enjoy tea at Eversfield Tea Gardens in Station Road. The lower photograph is taken in the same direction but from a lower vantage point. It captures part of the very successful 2010 street fair held in June. There is just enough background visible to show how shops have replaced the gardens behind the Cotswold stone wall which existed in 1937.

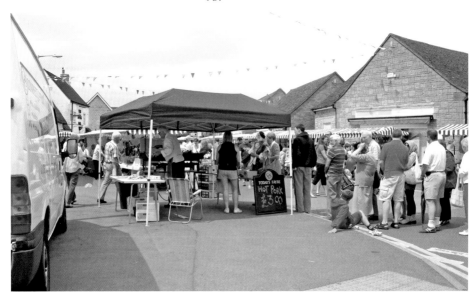

Ashton Court

Here is another view of the present war memorial site to complement those in our earlier volume. This photograph has been taken facing south, showing the front of the last remaining house on the site and, across Pecked Lane, the rear of Egremont, a fine early nineteenth-century house, and its timber-framed barn. All this was swept away twenty years ago. Egremont was replaced by a short-lived office block which in turn was replaced by these apartments, named after one of Bishops Cleeve's local families.

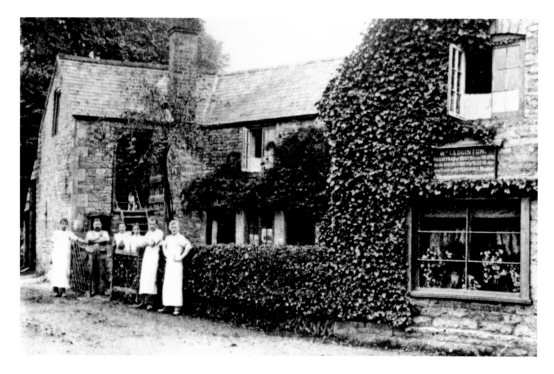

Edginton's Bakery

This was one of two traditional bakeries in Bishop's Cleeve. Denleys' bakery in Station Road was the second. There was a bakery here from at least 1830 until 1953. The photograph above was taken in 1905 with William Edgington standing second on the left. Ernie Freebery recounted in his reminiscences of Bishop's Cleeve in 1927 how the villagers could pay a few pence to have their Christmas goose cooked in the still-warm ovens. The site today is most clearly marked by the yellow lines on the road.

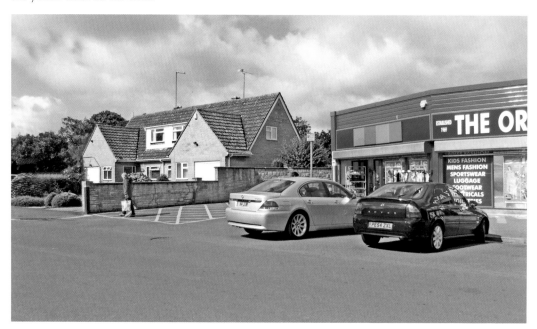

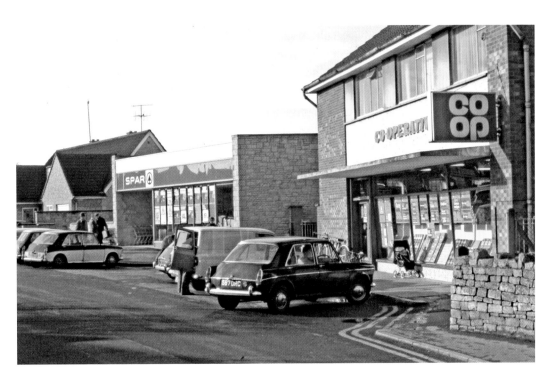

Two Shops

Peter Lewis, the retired head of art at Cleeve School, supplied photographs for our first volume. Here is another, taken in the mid 1970s, which provides an example of the increasing pace of change. The Spar supermarket had been built on part of the old bakery site in 1968, yet it and the Co-op are now in different hands. Note the number of British-built cars in Peter's photograph – another reason for its historic interest.

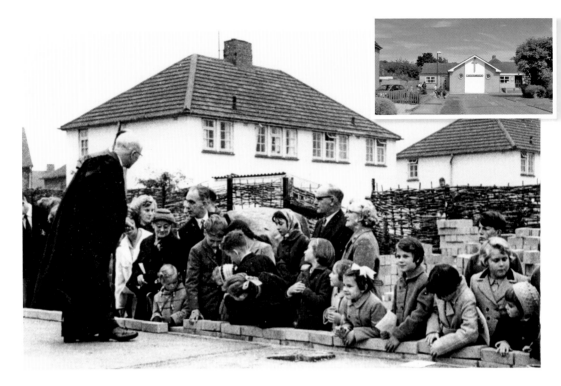

The Methodist Church

Further along Tobyfield Road into Smiths' estate can be found the Methodist church, set up in the early 1950s by incomers to the village. By 1958 their enthusiasm led to the building of the church and the upper photograph shows the stone laying ceremony taking place under the watchful eye of the minister, the Reverend Harry Holroyd. The lower photograph shows the congregation on a summer morning in 1986 posing for the camera. In 2008 the premises were updated to provide a modern worship area with rooms for community use.

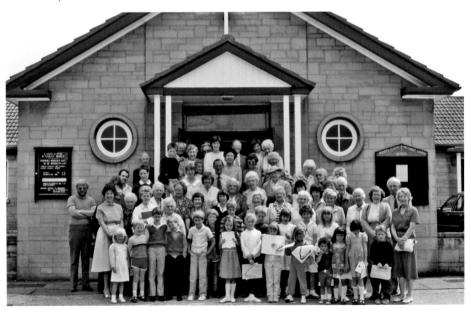

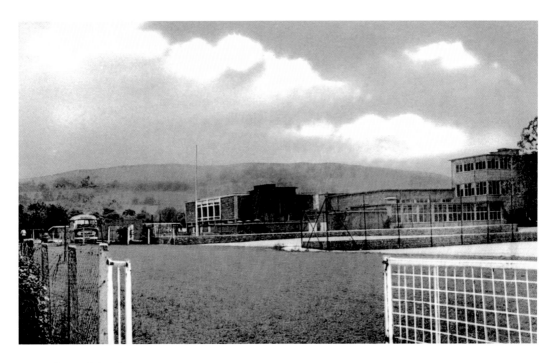

Cleeve School

In 1956 Bishop's Cleeve Secondary School opened in Two Hedges Road on the land of Lynworth Farm. Pupils who did not pass the eleven plus exam were no longer educated with the younger children in the Primary School in School Road (now St Michael's Hall). In 1965 the secondary school became a comprehensive school, taking all pupils over the age of eleven. In the twenty first century it has been substantially rebuilt to provide modern facilities for its fifteen hundred students. In the lower picture the top storey of the block on the right provides a reference point for the two scenes.

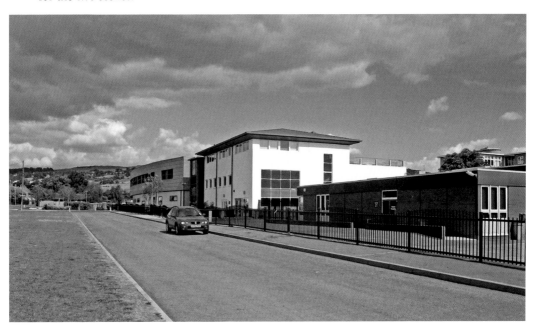

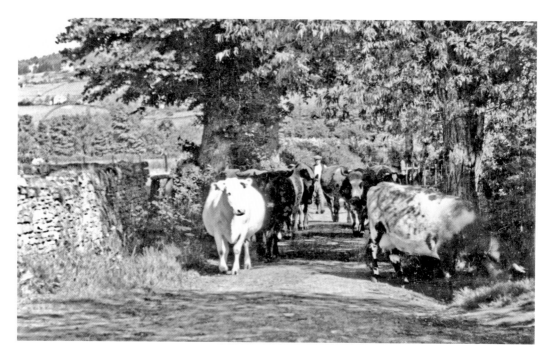

Pecked Piece Farm I

Bert Long's farm in Pecked Lane featured in our first volume. Here are two more pre-war photographs to remind us of the traditional life in the village. Bert can be seen here bringing his cows down the lane from the direction of the railway line. The scene today is largely unrecognisable but the hedge on the left before the lamp post grows where the wall stood over seventy years ago.

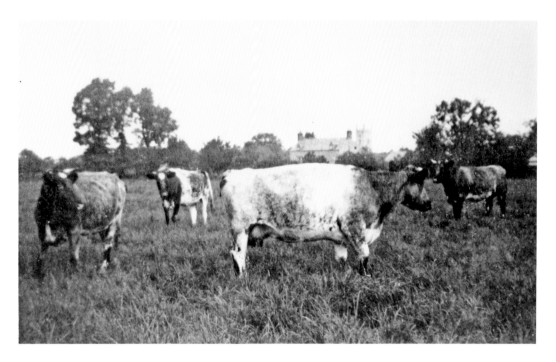

Pecked Piece Farm II

By relating the church tower to Fieldgate farmhouse and plotting it on a modern map, we have worked out that these cows were standing approximately where the tree, glimpsed between two bungalows in Pecked Lane, now grows. A photograph of such a rural scene as this in the village is very rare, but it reinforces just how much change there has been in the second half of the twentieth century. Bert sold his land for housing in 1954.

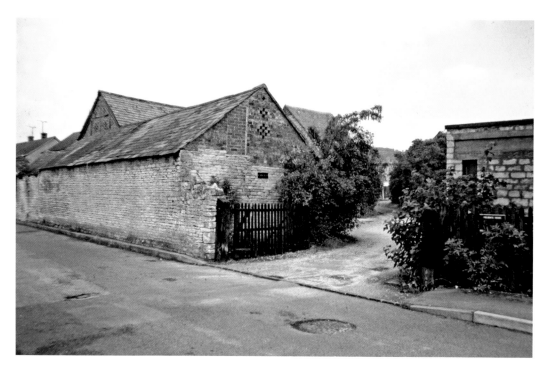

Fieldgate Farm Barns

Fieldgate Farm was the home of the Oldacre family from 1926 to 1958. According to Denys Charnock's account of the family, the yard contained a washhouse and pig sty with barns and stables. They were photographed by Bill Potter in 1978, shortly before demolition and the building of Ward Close which spread across the site.

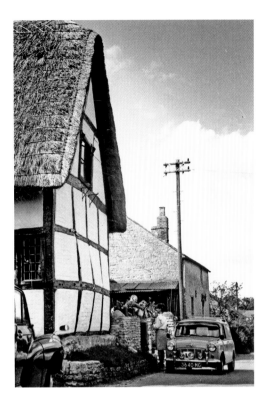

Priory Lane

St Michael's Cottage in Priory Lane reminds us that it belonged to St Michael's Church for several hundred years until the last century. It is the only remaining traditional timber-framed thatched building in Priory Lane and for many years featured a bowed wall seen clearly in the earlier photograph of 1960. The Cotswold stone cottage beyond it no longer stands; a small residential development now occupies its site.

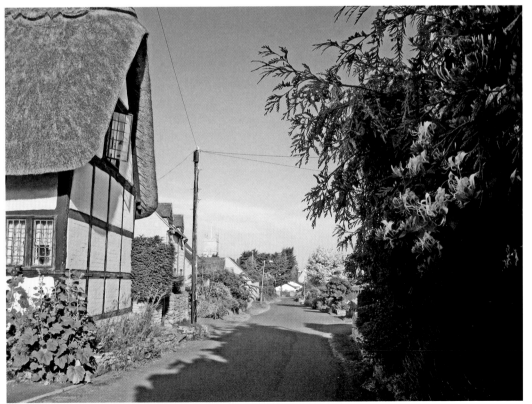

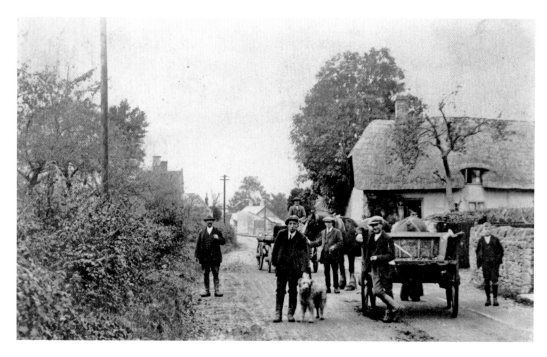

Station Road I

A group of villagers pose for a postcard in the early 1900s. Modern traffic prevents a reconstruction of the scene but it is still recognisable today. The timber-framed thatched house in the right foreground remains one of the best examples of its type in the village. It dates from at least the seventeenth century.

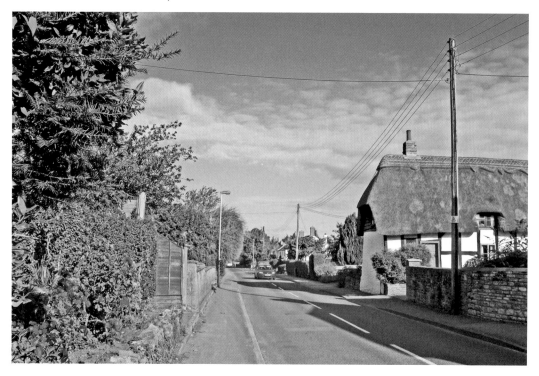

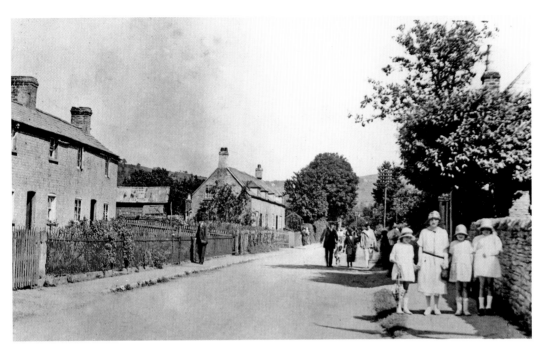

Station Road II

Eversfield Tea Gardens in Station Road featured in our first volume. Here a group of visitors have been caught on camera as they walked down from the railway station, sometime in the 1920s, to judge by the hats. From 1912 to the outbreak of the Second World War in 1939 Denleys' tea gardens provided the main reason why people visited the village.

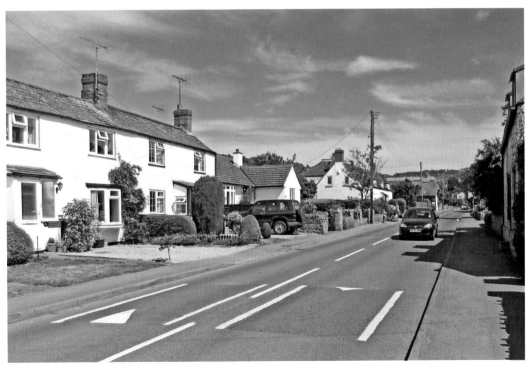

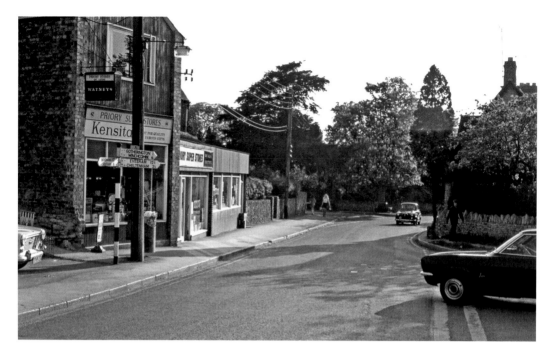

Priory Stores

Priory Stores at the end of the Gotherington Lane was another of the village's general stores which could not compete with the arrival of national supermarket chains. Photographed in 1978 the subsequent demolition of the flat-roofed extension has opened the view towards School Road.

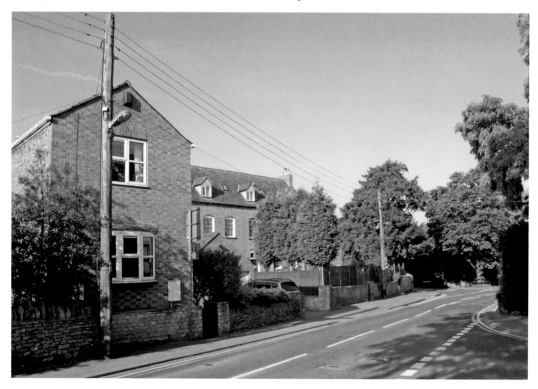

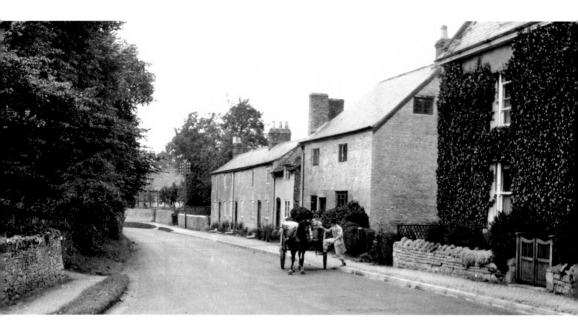

The Old Manor House

This lower part of Station Road was where 'the quality' lived in the nineteenth century. The Old Manor House was once part of the manor of Bishop's Cleeve and Haymes. In 1778 it was described as 'a good farmhouse of stone and slate'. However the small wing just off picture at the side possibly dates from the 1400s. The small terrace of agricultural labourers' cottages in the middle distance was built in the early nineteenth century.

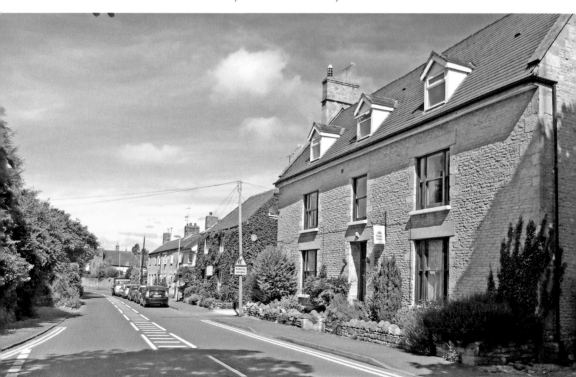

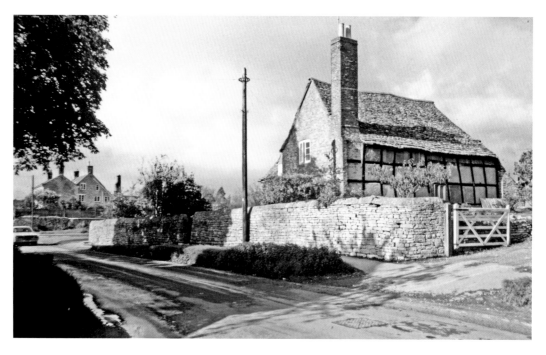

Cleeveland's Farm

Seen in the distance in the previous photographs, 23 and 25 Station Road made up the farmhouse of Cleeveland's Farm before the land was built upon in the 1960s. As we wrote in our first volume it was the home of the Minett family for many years until in 1942 it was taken over by Oldacres. Timbers inside indicate that the building, like parts of the Old Manor House, probably dates back to the 1400s. Until 1837 a stream ran down this part of Station Road.

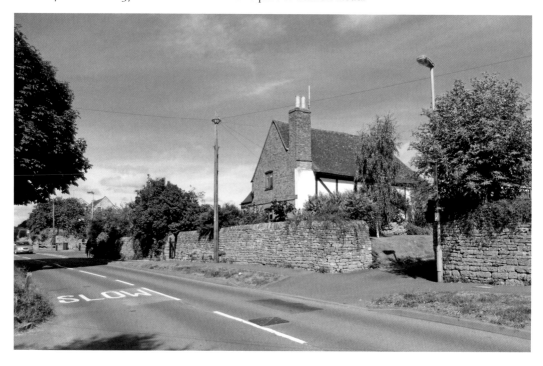

Bishop's Cleeve Bypass

As we leave Bishop's Cleeve we return to a topic first discussed as far back as 1926 – that of a bypass. In 1926 this was proposed to avoid Gilders' corner, but when it was finally built in 1991 it was as an integral part of the expansion of the village to the west. A century and more ago, Anchor Cottage, seen in both photographs, sold beer. It was then known as Waddow Hole.

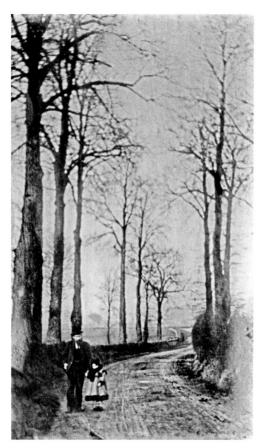

Gotherington Lane

Although the quality of the top photograph leaves something to be desired, it merits inclusion as it shows how Gotherington Lane was once little more than a track bounded by tall trees. This photograph dates from the early twentieth century. Not until the arrival of the British, then the US, army camps along the lane in the early years of the Second World War, did the lane take on its present condition. Only the distant bend in the road serves as a common feature in both scenes.

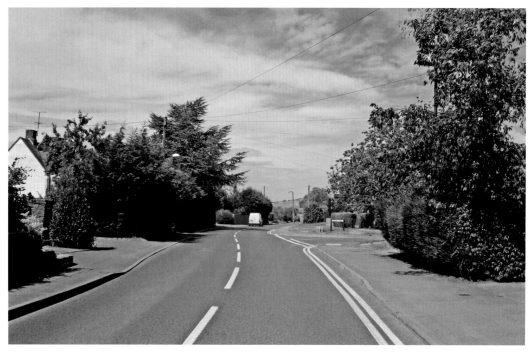

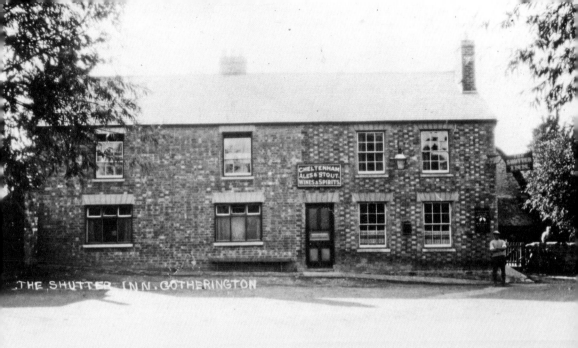

CHAPTER 2

Gotherington and Further Afield

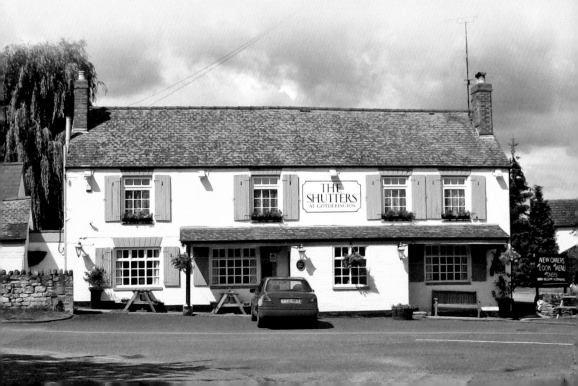

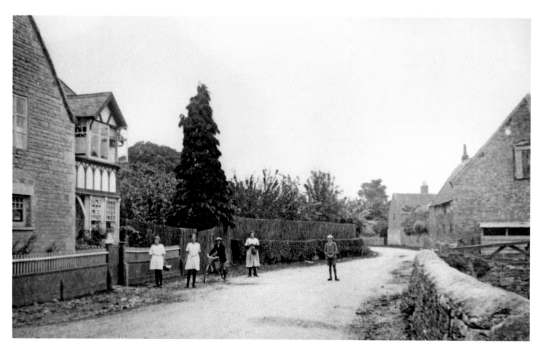

The Gables

We know the names of the children posing for the photographer in Cleeve Road outside The Gables sometime in the 1920s. Maud Long, Joan Dowding, Gordon Pullen, Doris Dowding and Bert Long. Bert has already featured in our photographs of Pecked Piece Farm. For many years the Ryman family ran the village shop from The Gables before it moved to its present location just off picture to the left.

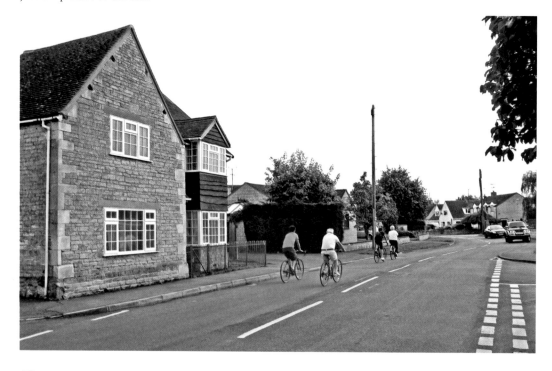

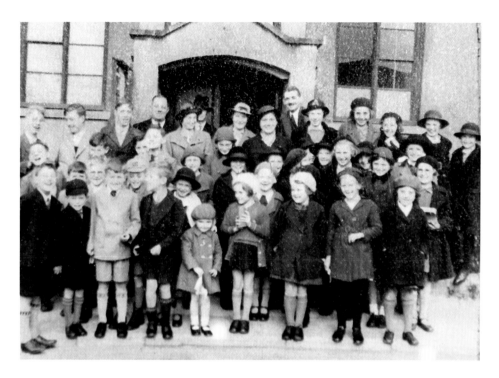

Gotherington Free Church

There has been a chapel on this site in Gotherington since 1830. The top photograph shows the congregation of the chapel in 1939, the year war broke out. The lower picture was taken in or shortly after the war as the name 'Gotherington' has been blacked out on the war memorial. Today the timber-framed building on the right has gone and the chapel is used only on special occasions.

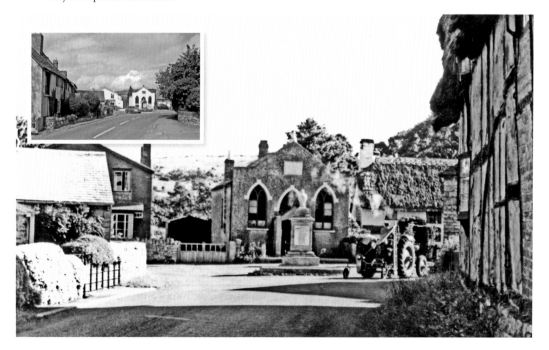

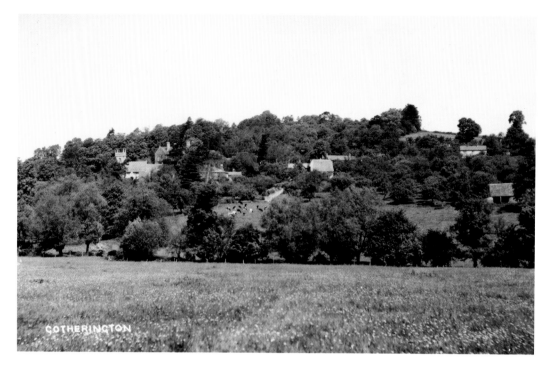

Woolstone

It is difficult to imagine that any visitor buying this postcard in the 1950s would be confused enough to think the scene was of Gotherington despite its title! Taken from the Gotherington side of the Tirle Brook, the modern view shows that many of the buildings, bushes and trees are still there, but the large arable field has been created from the tree pasture of the earlier date, and the barn has gone.

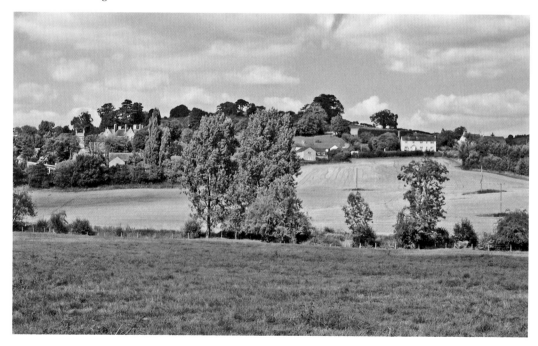

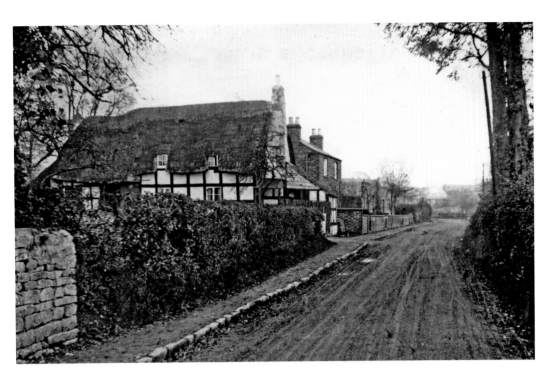

Malleson Road

This fifty year old scene is still recognisable today although new houses have appeared in the distance. Elm Cottage is one of a number of sixteenth and seventeenth century timber-framed buildings still standing along Gretton and Malleson Roads. It lost its kitchen when the road was widened. The lower scene shows how Gotherington is now on the circuit of the very popular modern leisure activity of Sunday morning cycling.

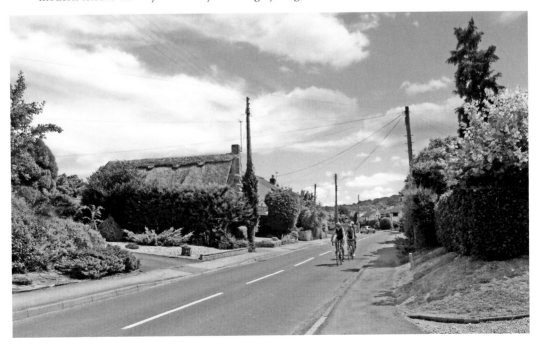

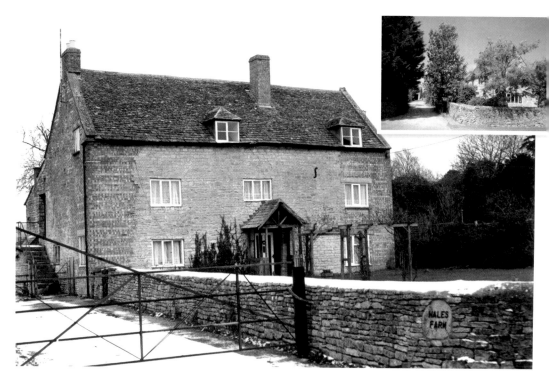

Hales Farm

Hales Farm was first recorded in the twelfth century but the building captured being carefully demolished in 1997 probably dated back only to the early nineteenth century. In 1851 William Harman lived here and farmed twenty five acres (10ha). Today two houses fill the site but fields still lie behind them.

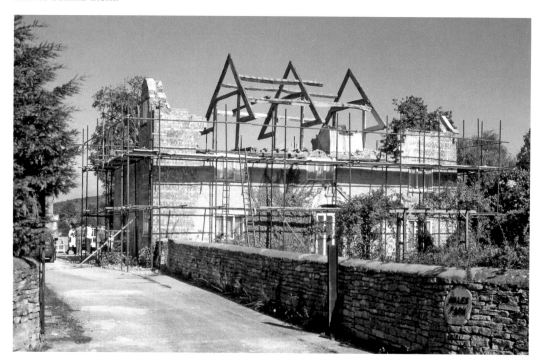

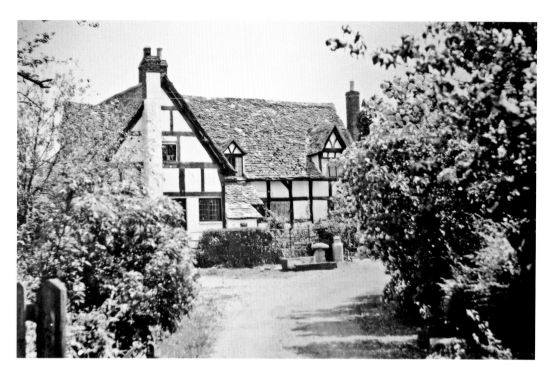

White's Farm

Here is another farm which exists in name, but which no longer functions as it did when the upper photograph was taken some sixty years ago. Note the rather obvious milk churn in front of the house. White's Farm belonged to the community of Lower Gotherington which was clustered around Shutter Lane and it probably dates back to at least the 1400s.

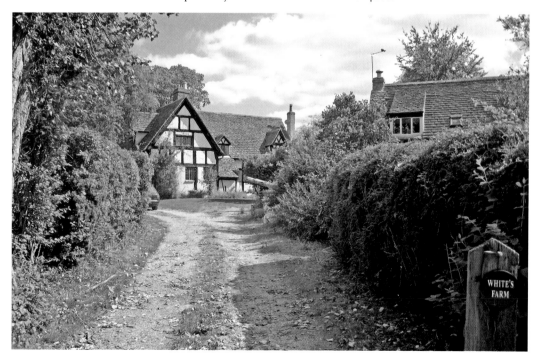

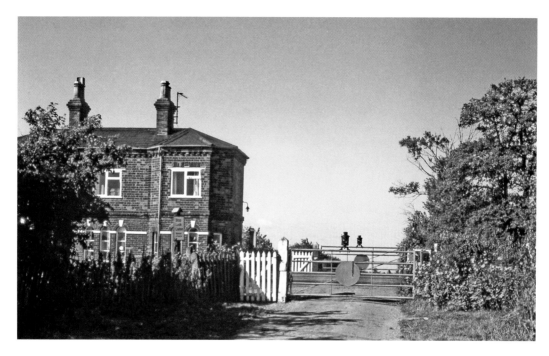

Tredington Crossing

By continuing out of the village across the A435 road we can come to the Tredington railway level crossing. Nothing now remains of the original 1840 crossing keeper's cottage, photographed in 1978 when the gates gave priority to the trains. This meant that they were manually opened for each passing vehicle and so the crossing was manned for twenty-four hours a day. The modern automatic barriers clearly save on expense but are nowhere near as photogenic.

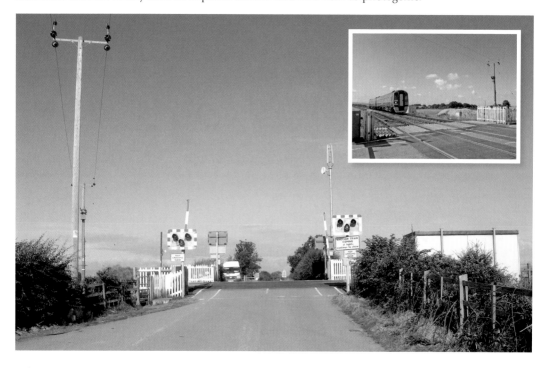

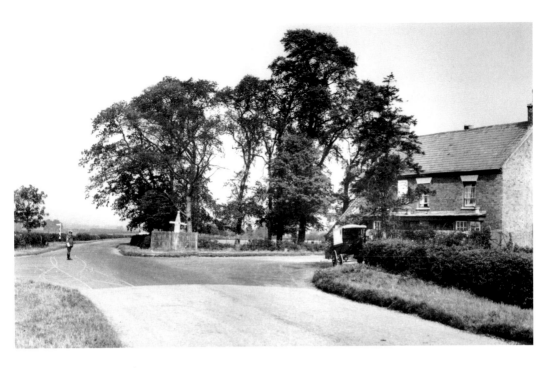

Teddington Hands

If we travel along the A435 we shortly arrive at Teddington Hands, named after the elaborate finger post which is just visible. It was erected by the Attwood family over three hundred years ago. Our earlier photograph dates back to 1930 and shows RAC man Harry Evans posing for the camera. A horse-drawn butcher's cart stands outside the inn. The inn is still a popular destination today, but the road junction has been completely remodelled and it is now a very busy roundabout.

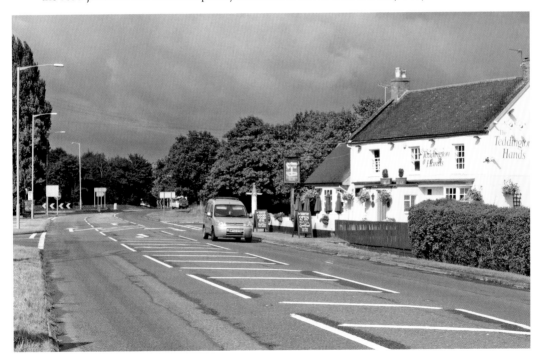

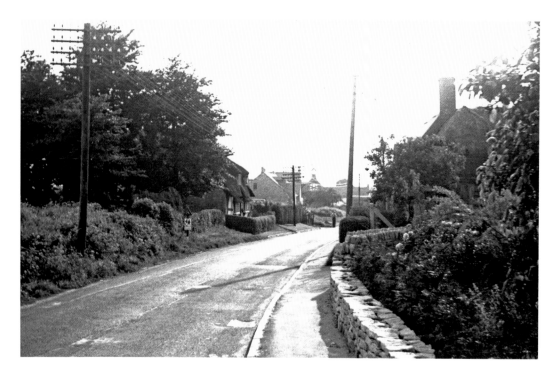

Gretton Road

We are now back in Gotherington and along Gretton Road in this photograph taken half a century ago. Elm Tree Cottage, another traditional timber-framed house, on the left and Baldwins' farmhouse, on the right, are still recognisable. The entry to The Lawns appears in the lower photograph, which itself will be of historic interest in the future, as it captures the building of an extension to Elm Tree Cottage.

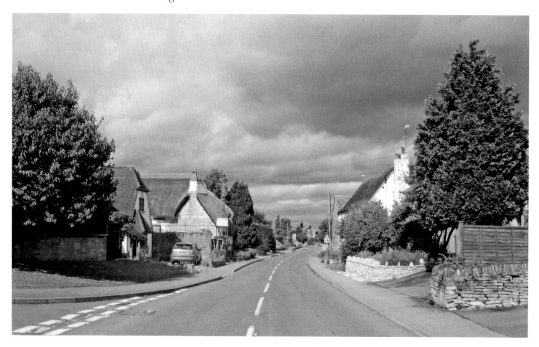

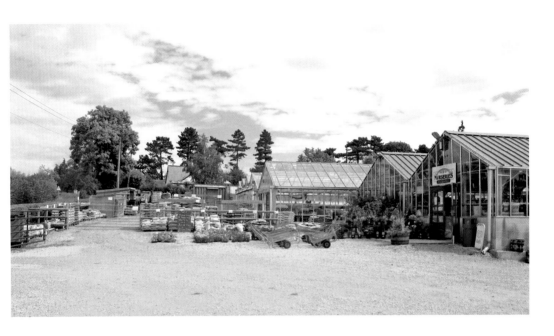

Gotherington Nurseries

There has been a market garden near Gotherington station since shortly after the opening of the railway in 1906. This provided a speedy link to markets in London and the Midlands. Today it is a successful garden centre, as seen in the upper picture. However the site was derelict when it was taken over by Mark Tsakarisianos in 1986, as the lower photograph shows. The white gable end of the house in the distance provides a point of reference for both views.

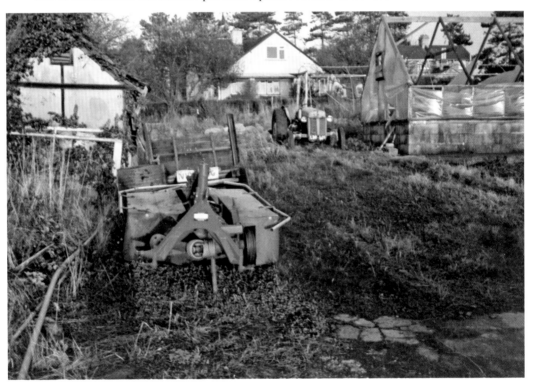

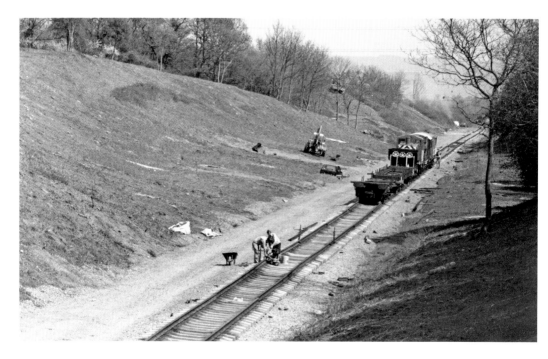

Dixton Cutting

The railway line through Gotherington was closed by British Rail and the metals removed in 1979. It later reopened and is now worked as a successful steam heritage railway by the Gloucestershire and Warwickshire Railway Society. Here we see a team of volunteers working on the Dixton cutting in 1996 and the later picture showing the fruits of their labours. 'Black Prince' with its rake of coaches is about to pass under the Dixton road bridge.

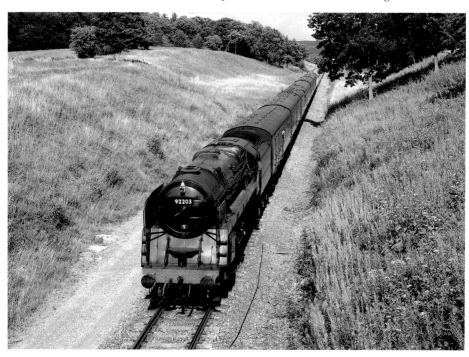

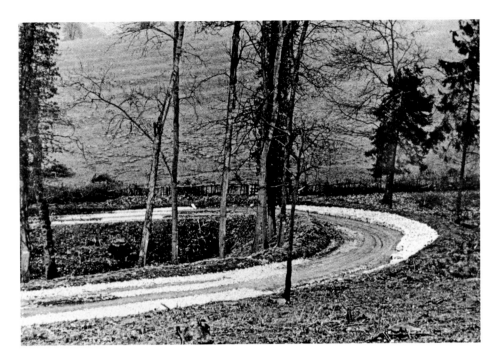

Prescott Hill Climb

In 1937 work began on constructing a hill climb on the approach drive to Prescott House by its new owners, the London-based Bugatti owners' club. A series of photographs was taken as the work began and the view here is of the Orchard Corner, later to be bypassed in 1960 by extending the track further up the hill with a new bend christened Ettores.

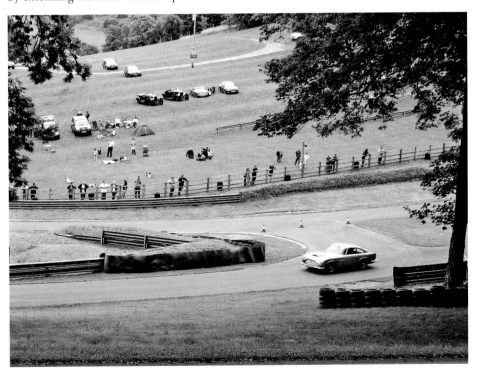

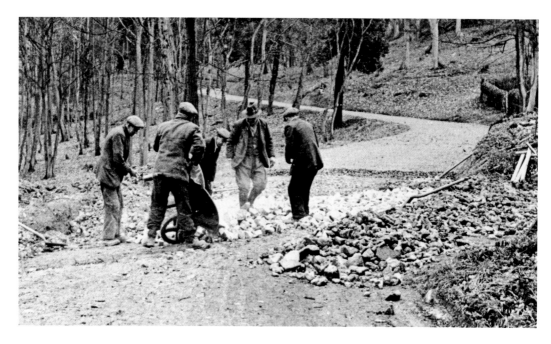

The Esses

The driveway to Prescott House snakes through the trees towards the hill's summit. In the top photograph a team of workmen are busy consolidating its surface in readiness for the first cars to compete in the following spring of 1938. The modern track follows the same tortuous line and this section is referred to as The Esses.

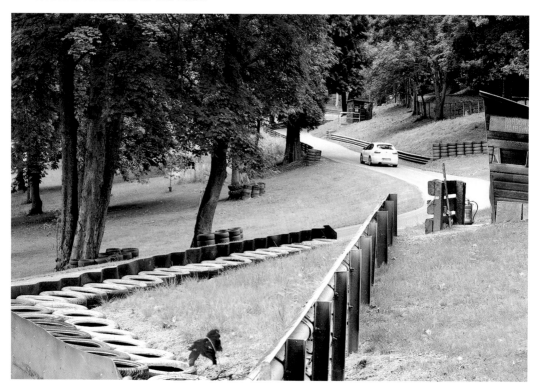

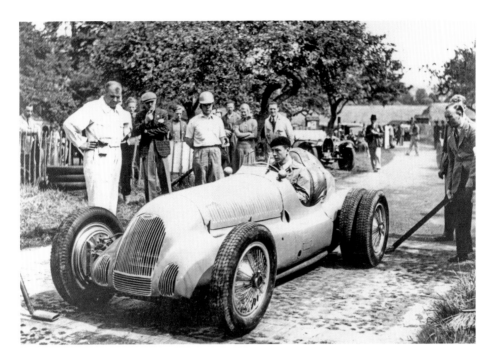

The Starting Line

In July 1939 the Bugatti owners' club mounted an international meeting and the Bugatti factory sent over from France its latest powerful Grand Prix car, a 4.7 litre supercharged model, seen here on the start line with the French ace Jean-Pierre Wimille at the wheel. History repeated itself nearly seventy years later when a new Bugatti supercar built by Volkswagen was brought to Prescott in 2007.

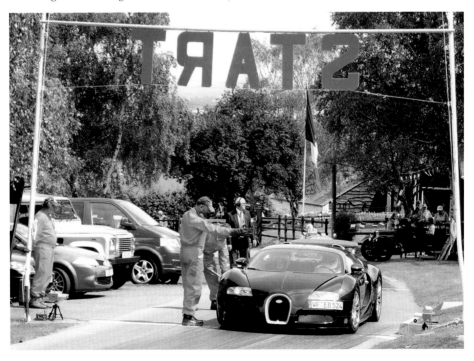

The Orchard

The lower slopes of Prescott Hill were clothed by an orchard, through which the original drive wound its way. Today cars leaving the start line head under a pedestrian bridge towards the first sharp bend, appropriately still called The Orchard.

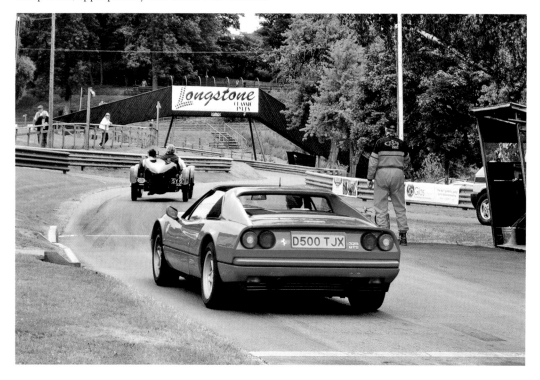

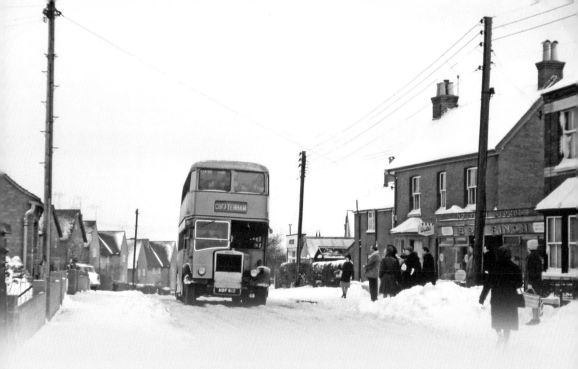

CHAPTER 3

Woodmancote

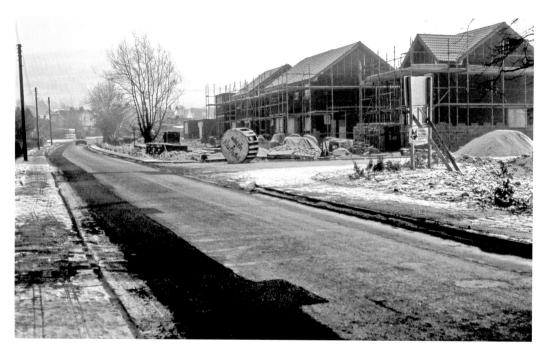

Station Road

This photograph from 1981 shows the development of the south side of Station Road well underway. Soon the village character of this stretch of Station Road will be lost as indicated in the modern photograph which shows the roundabout at the bottom of Britannia Way. Out of sight behind the camera traffic calming humps are intended to slow the traffic even more on this busy road.

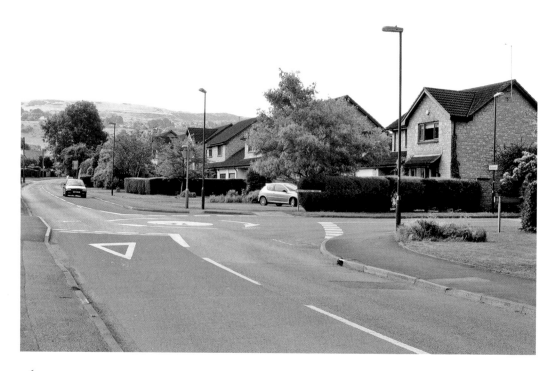

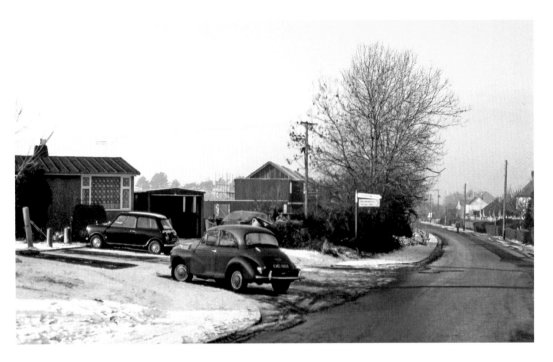

Crowfield and Station Road

As explained in our first volume, twelve prefabs were built on Crowfield in 1948 to help ease the post-war housing shortage. They were only demolished in 1990 making way for a dozen warden-controlled homes. The upper picture, taken on Christmas day 1981, shows the start of the prefabs' access path and the tiny parking area to cater for any tenants who may have owned a car in 1948. The picture also shows houses being built on the south side of Station Road. The lower picture shows how they are now obscured by maturing lush greenery.

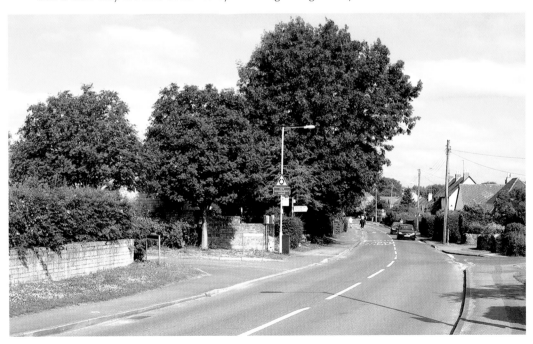

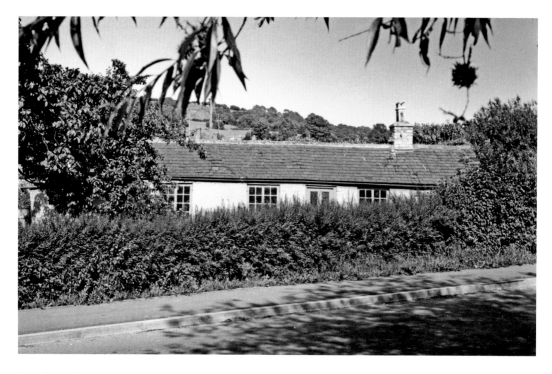

Beard's Ash

The charming cottage of Beard's Ash probably started life as a squatter cottage in the early nineteenth century, where Bushcombe Lane joins Station Road. It was photographed in 1965 just before its demolition and replacement by a pair of detached bungalows.

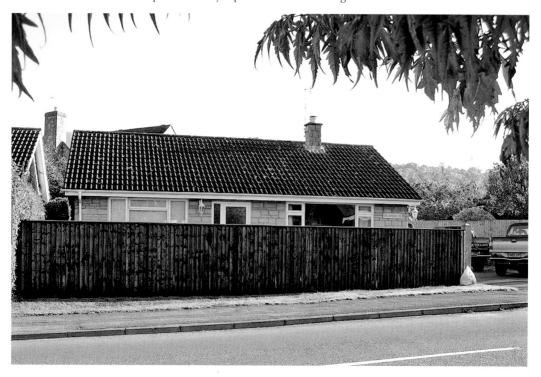

Roseville

Our first volume included a photograph of the front of Roseville in Bushcombe Lane. Here is the view from the rear. Roseville was for many years the home of Jim and Annie Surman and their large family before it was demolished in 1968, when the site and the land attached became the Aesop's Orchard development. The new access road off Bushcombe Lane was built across the spot where Roseville once stood.

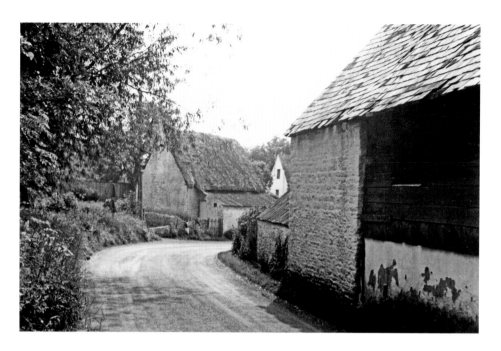

Mrs Parker's Cottage

The dilapidated cottage on the corner in Bushcombe Lane was always referred to as Granny Parker's cottage. The old lady lived a very frugal lifestyle there and kept a few hens which scratched about in the small paddock by the stile. It is photographed here in 1969. On her death the cottage was all but demolished, with just one wall left standing and our modern picture shows the new property which rose in its place. On the right stand the restored barns of Yew Tree Farm.

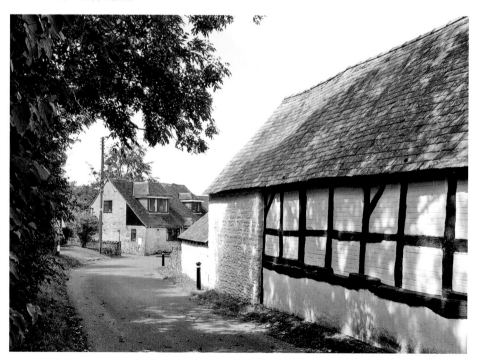

View From Bushcombe

The earlier scene was photographed in June 1972 from the lower slopes of Bushcombe Hill looking across Breeches Lane to the Longlands and beyond to Bishop's Cleeve. In the foreground are the two greenhouse nurseries belonging to Leonard Surman. On Leonard's death the nurseries were demolished and, together with the Longlands field, the area has since been developed into high density housing.

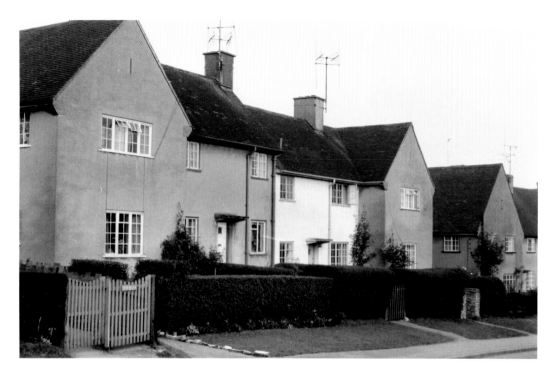

Nutbridge Cottages

The row of twelve semi-detached and terraced properties on Station Road, known as Nutbridge Cottages, was erected by Cheltenham Rural District Council in 1937-38. The earlier picture was taken in 1972 when some were passing into private ownership and shows numbers 5-9. Today that process is complete and they have been individually restored with many of the front gardens turned into vehicle hardstandings.

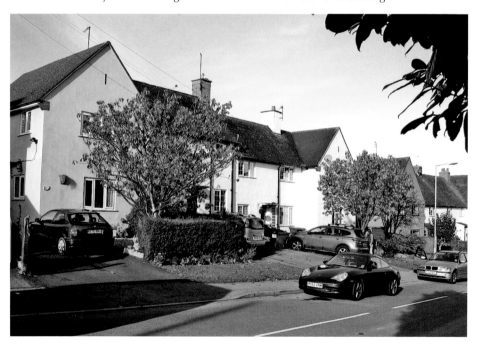

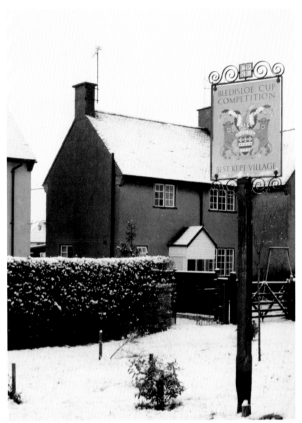

Bledisloe Cup

In 1976 Woodmancote was awarded the Bledisloe Cup for the best-kept large village in Gloucestershire. A sign was erected in front of Nutbridge Cottages to commemorate the achievement. The hapless residents adjacent had to enjoy much good-natured teasing with suggestions that their home had been turned into a public house!

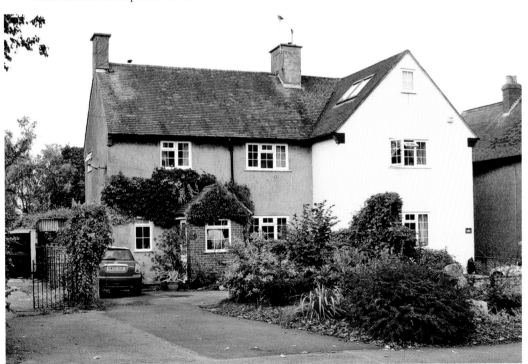

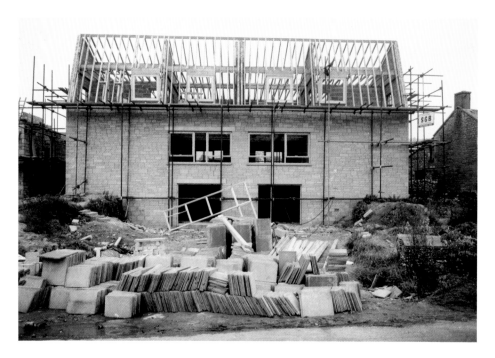

The Sonnings

A large stone detached house once stood by the green in Woodmancote with a large garden stocked with flowers and trees; the property being set off by an attractive Cotswold stone boundary wall. When the house was demolished and replaced by the three storey property shown here in the mid-1960s, there was an outcry in the village and the result was an attempt to soften the height of the houses by raising the front gardens, as seen in the lower picture.

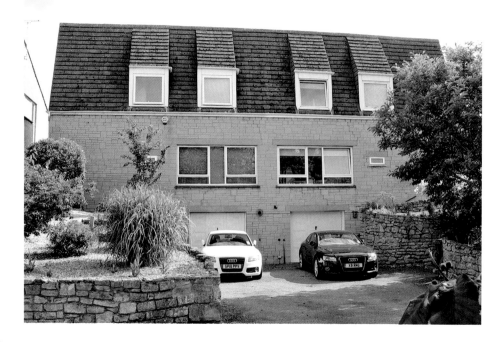

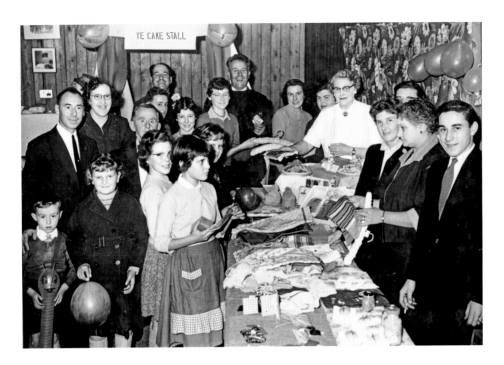

The Old Village Hall

Woodmancote old village hall was built in 1923 through the efforts of a committee of local stalwarts. This modest little building in Stockwell Lane has hosted many events in the life of the village: whist drives, wedding receptions, local society meetings and as a voting station. The upper photograph was taken in 1958 and shows a sale of handicrafts, bric-à-brac and the like, organised by the Countess of Huntingdon's Chapel from further up the lane.

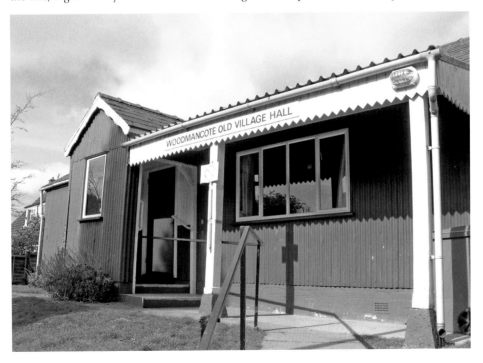

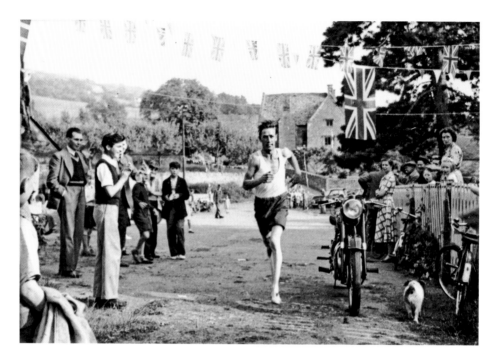

The Apple Tree Car Park

During the celebrations for the coronation of Queen Elizabeth II in 1953, a race was run around the lanes of Woodmancote, starting and finishing outside the Apple Tree Inn. Here the winner, Jim Hart of Brook Cottage in Chapel Lane (pictured in volume one), strides under the bunting to cross the finishing line. Notice the rough, rustic nature of the pub yard and the railings, long gone, in front of the inn. Out of the picture to the left was a pond teeming with newts and frogs. Today all this is but a car park.

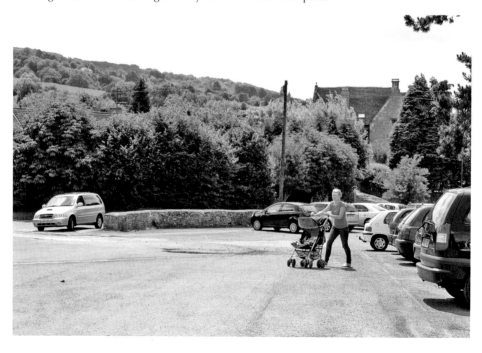

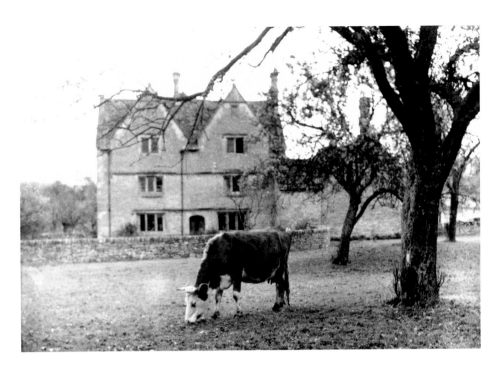

Woodmancote Manor

There never was a true manor in Woodmancote and this largely seventeenth-century building adopted the name at the end of the nineteenth century. The early photograph was taken around 1950 when it enjoyed an open aspect to the west across the adjacent orchard, where cows could gorge in the late summer on the fallen fruit. Within two decades the orchard had vanished to be replaced by Hillside Gardens and parked cars stand where once the cattle grazed.

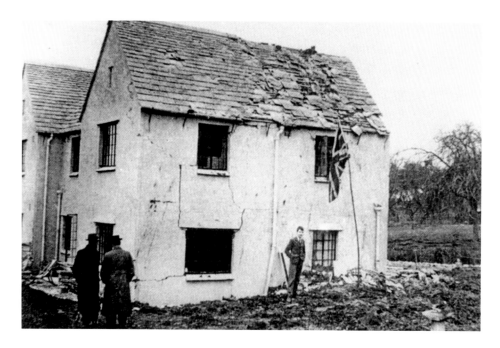

Haywards

In November 1940 Woodmancote experienced the dropping of a string of bombs across the village by the German Luftwaffe. Local folk memory recalls the reason being a stray aircraft lightening its load in a desperate attempt to clear Nottingham Hill. Severe damage was caused to Haywards, a large detached house opposite the Apple Tree Inn in Stockwell Lane. At the time of the bombing the house was newly-built for Major Woolley and his family. Today the house belies its violent history, as seen in our picture of its immaculate frontage.

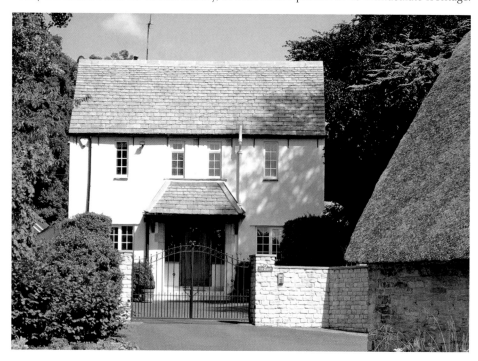

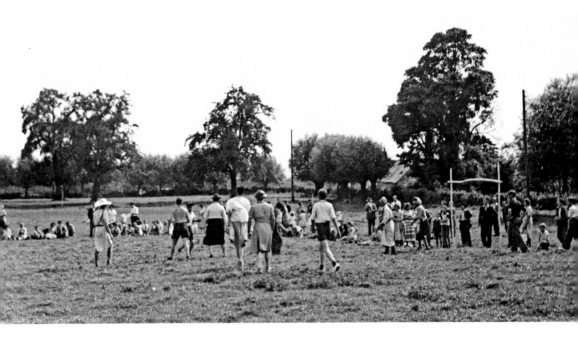

Potter's Field

Potter's Field adjoined King's Farm on Woodmancote Green and for many years served as the village's unofficial recreation ground, as we explained in our first volume. Flower shows and fêtes were held here and the Woodmancote cricket team adopted it as their home ground. Here we see a village sports day in full swing around 1950. After being developed as a housing estate, no trace of its former uses remains.

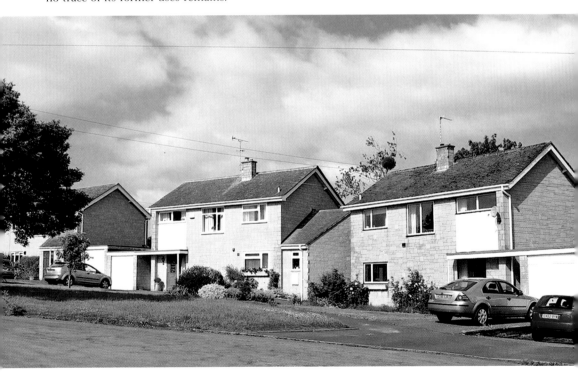

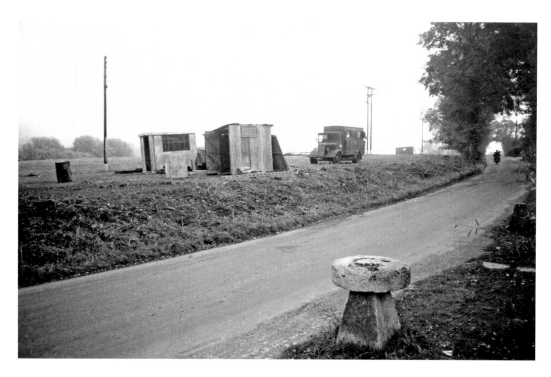

Pottersfield Development I

Here follow two more views of the developments off New Road to complement the views in our first volume. The first is the view of Potter's Field just as development began in 1965. It was taken from outside Poplar Farm. Remarkably the staddlestone remains as a reference point, although by now it is missing its mushroom-shaped top.

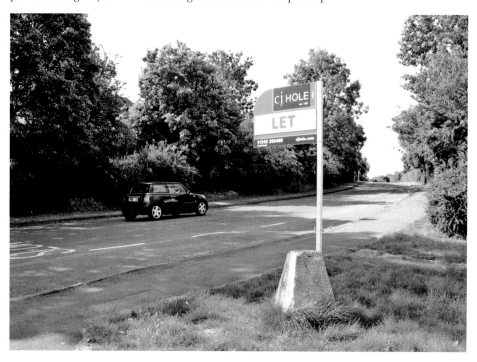

Pottersfield Development II

Here is a further photograph taken in 1965 when the builders have moved on to the site in readiness to start building the houses in the years before Health and Safety legislation! The later picture shows the same view forty-five years on, by which time the housing estate has much mellowed by the planted trees and hedges.

Two Hedges Road

Two Hedges Road was very aptly named, as the photograph taken about 1971 illustrates. Within the following decade this all changed. Britannia Way now has its junction with Two Hedges Road and houses of the new estate abut the right-hand side of the road as one travels towards Bishop's Cleeve.

Chapel Lane Footpath

At the bottom of Chapel Lane a rustic
stile led over a stone slab bridge
to the field path beyond. This still
provides the most direct route from
Woodmancote Green to Bishop's
Cleeve. It crossed pasture which had
lain undisturbed for over a century
and was patterned with the corduroy
of medieval ridge and furrow. In the
early 1970s the developers moved in
and the fields are no more. Behind the
tall bushes in the lower picture is laid
out the large Woodmancote Vale estate.

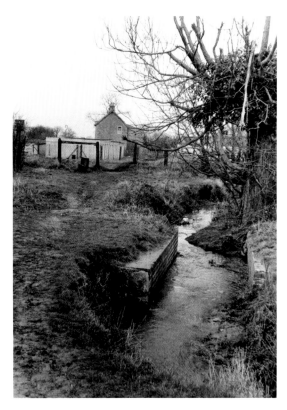

The Brook

As we noted in our first selection, a tinkling brook kept company with the footpath, which crossed from Woodmancote into Bishop's Cleeve via a culvert under the railway line. The earlier photograph was taken in March 1972. The recent photograph shows the same brook passing through a large empty lagoon designed to hold any overspill of water during times of heavy rainfall and thus protect the houses of Woodmancote Vale from potential flooding.

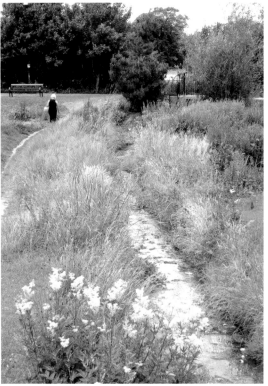

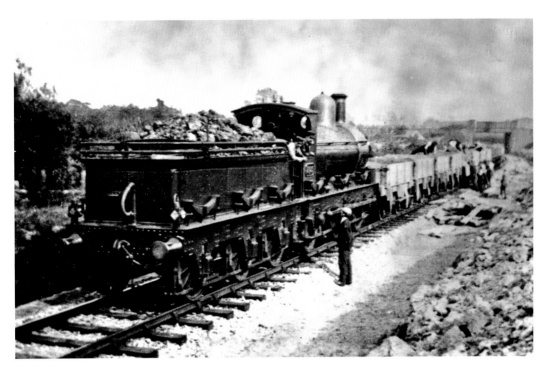

The Railway

The top picture represents a rare view of work underway around 1905 by the Two Hedges Road railway bridge, showing the construction of the Great Western Railway main line from Honeybourne to Cheltenham. The northbound express in the lower photograph has just cleared the same bridge, hauled by the locomotive 'Earl Baldwin' *en route* from Newquay to Wolverhampton on a summer Saturday in July 1964. The inset picture shows thick bushes obscuring the housing development of Woodmancote Vale, where once the apple orchards flourished.

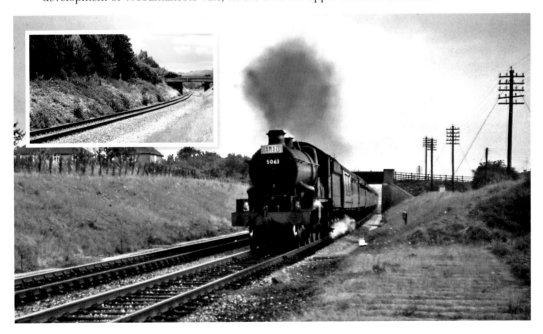

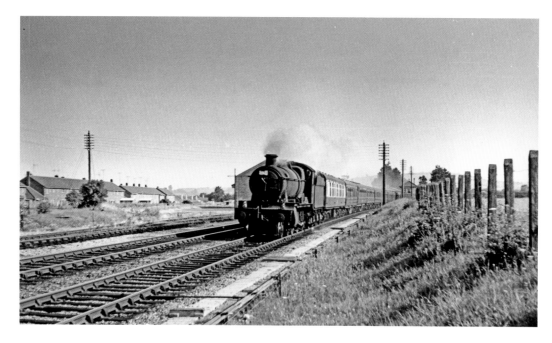

A Summer Express

In another photograph from July 1964 a southbound express from Wolverhampton to Ilfracombe, hauled by 'Bucklebury Grange', passes through the site of Bishop's Cleeve Station. Just visible behind the locomotive is the large goods shed and to the right of the train is the stone-built signal box. In the late 1960s the redundant goods yard and shed were swept away and the Woodmancote, Southam and Cleeve Hill Royal British Legion built their long-awaited clubhouse and car park on the site.

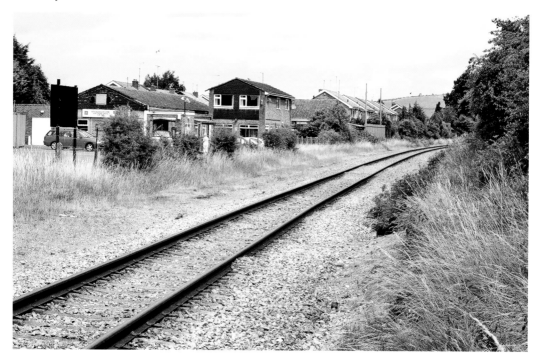

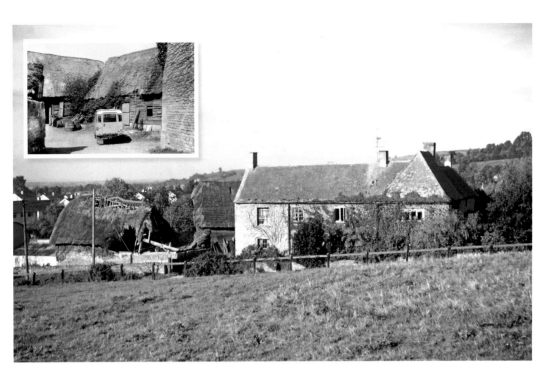

Lower Bottomley Farm

Lower Bottomley farmhouse is seen here from the field across Gambles Lane in the mid-1960s. Its outbuildings were then in an advanced state of decay and were demolished soon after the picture was taken and their site was absorbed into the Pottersfield development. The inset is a glimpse into the farmyard from Gambles Lane, showing the barn which housed a traditional cider mill and press.

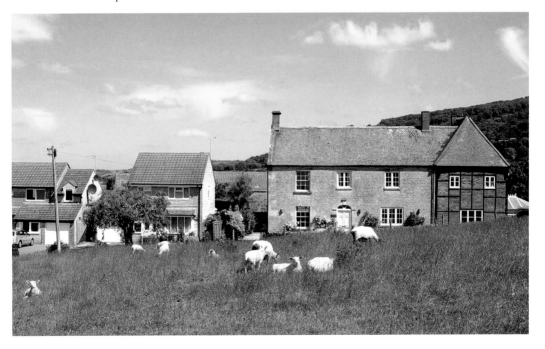

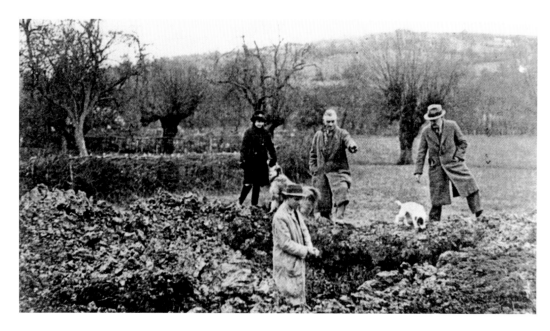

The Bomb Crater

When the German bomber dropped the string of bombs across the village in November 1940 which caused the damage to the Haywards, the first bomb to land exploded harmlessly in the field behind Lower Bottomley Farm. A posed photograph taken the following morning shows farmer John Denley and his dog, with George Organ from neighbouring Manor Farm, actually standing in the crater itself. Today sheep lie at ease in the depression and the residents of the later Hillside Gardens are generally unaware of that chilling autumn night in 1940.

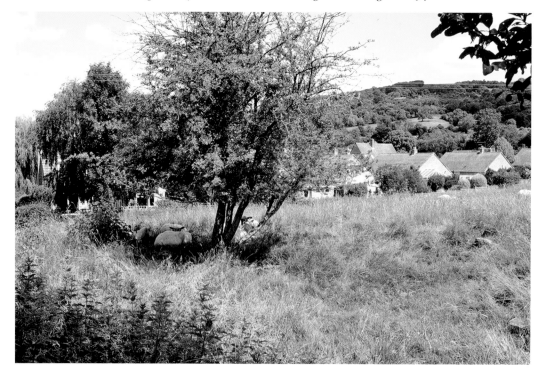

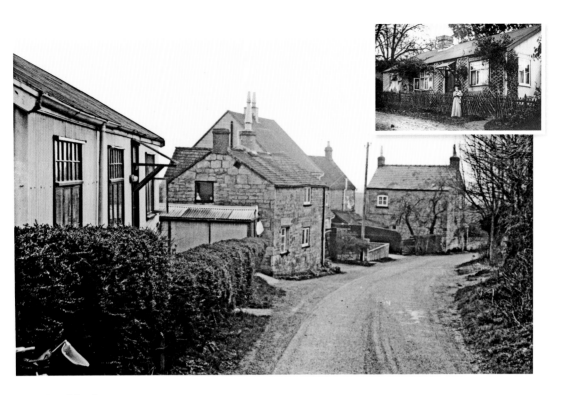

Gambles Lane

This tiny cluster of cottages lines Gambles Lane on the edge of the Haymes estate and it is pictured here in 1972. In the succeeding years the cottages have been heavily restored and extended. The house on the extreme left was Capricorn, a large Edwardian-style bungalow constructed of corrugated iron. Our inset shows it in the 1920s. It was demolished in 1986 and replaced by the large detached house and double garage which today occupy the site.

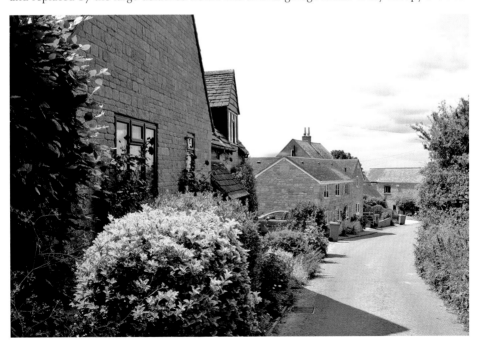

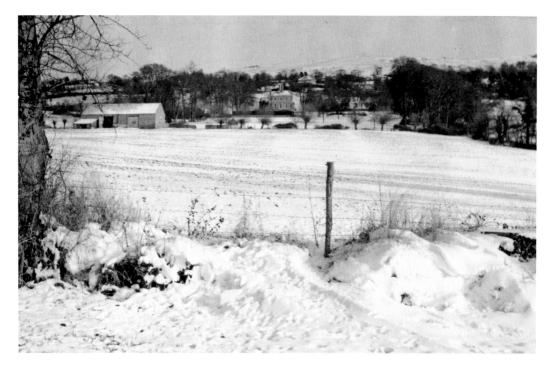

Haymes

Haymes farmhouse is but a remnant of a large house built in 1733 by lord of the manor, William Strachan. It is seen from New Road in the snows of 1947 and then twenty years later, when sheep were still grazing peacefully in the fields below the house. Today the metalled drive to the mushroom farm has replaced the winding farm track and the attractive view is lost.

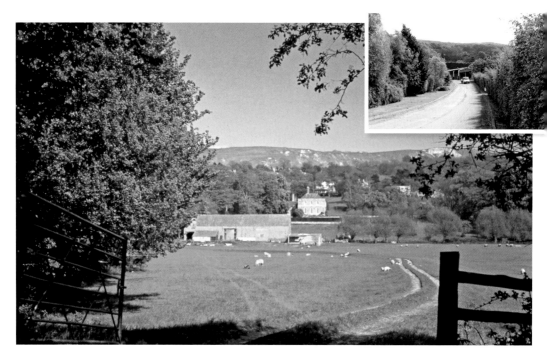

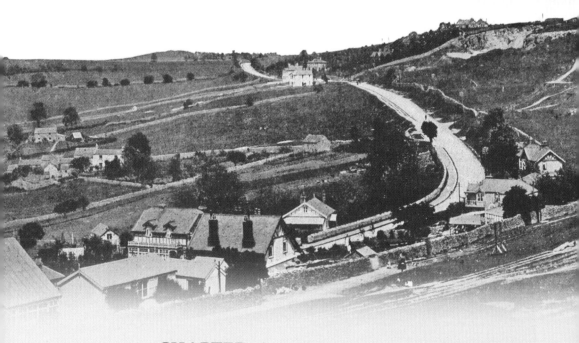

CHAPTER 4

Cleeve Hill and Southam

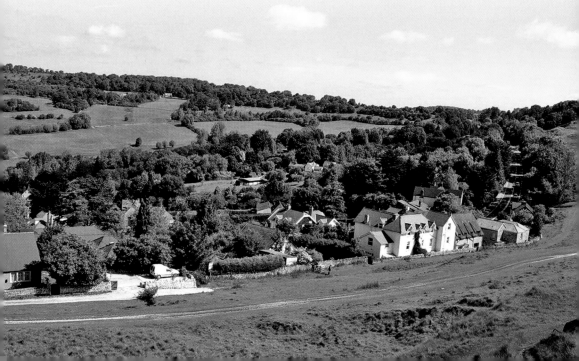

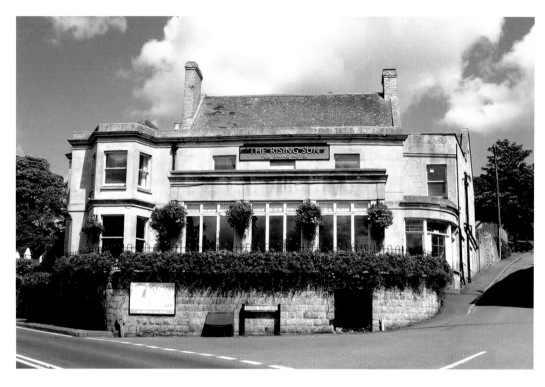

The Rising Sun

The Cotswold Hounds met at The Rising Sun Hotel on Wednesday 15 November 1905 for what appears to be something of a social occasion for the local gentry. Over sixty six years later the hotel is the venue for a quite different sporting event, the Whitsun Road race of 1972. In the lower picture we see the final straggler making his way to the bar door to the right of the building.

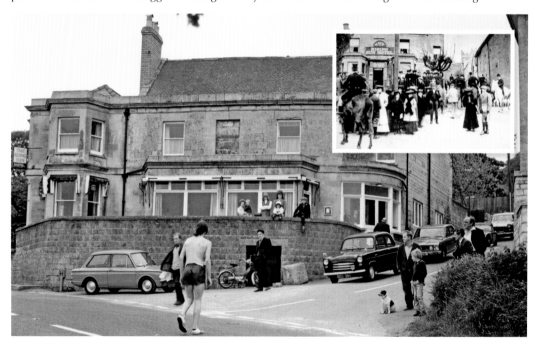

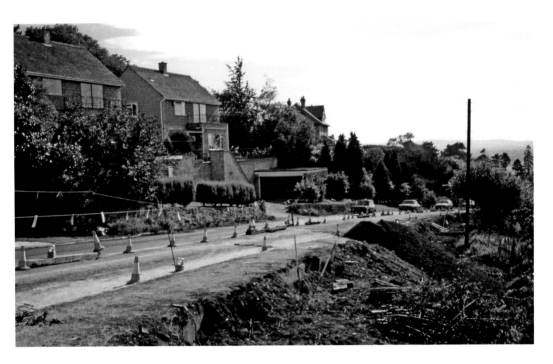

The Cleeve Hill Road

The peculiar geological structure of Cleeve Hill has resulted in the upper slopes of the scarp being notoriously unstable. In 1985 a major rebuilding project was undertaken on the main road to consolidate the foundations of this important link between Cheltenham and Winchcombe and further afield. Today the casual observer is probably unaware of the massive pile-driving that took place to stabilise the road at this point.

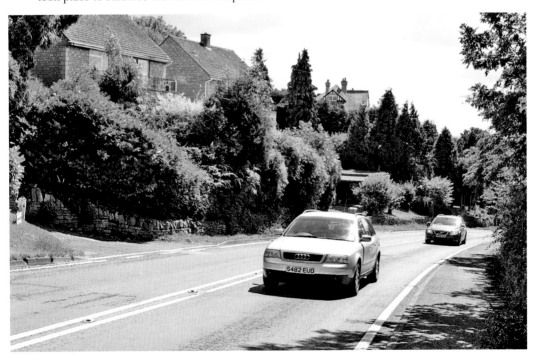

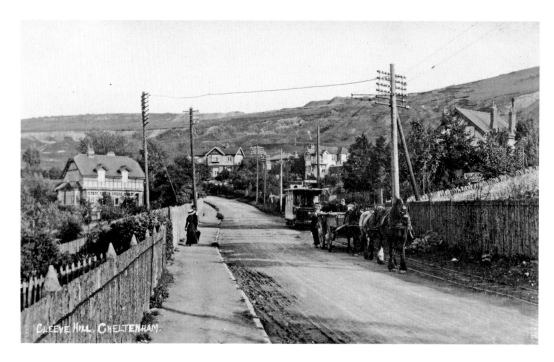

The Tram Terminus

A single-decker car waits outside the Malvern View Hotel before the First World War, whilst a heavy wagon belonging to local entrepreneur Arthur Yiend approaches the camera. In 1947 a heavy winter frost emphasises the cat's cradle of telephone wires emerging from the Cleeve Hill exchange in nearby Post Office Lane, which closed in the 1960s. In the modern scene one of Marchant's familiar double-decker buses passes the site.

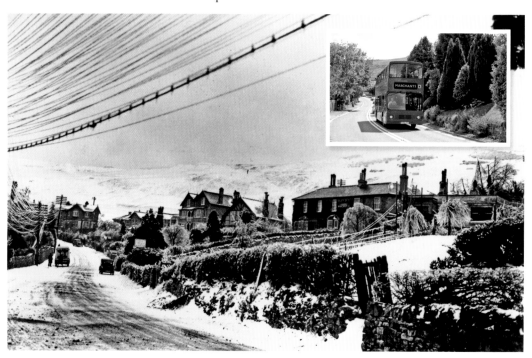

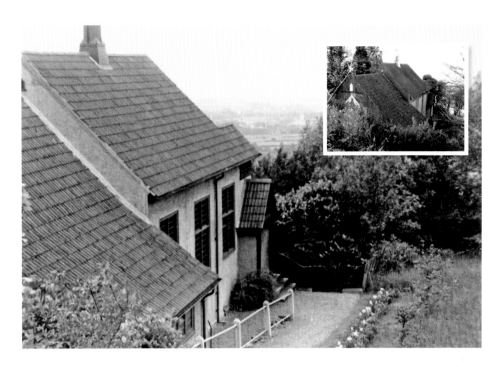

St Peter's Church

St Peter's Church was opened for worship in 1907 and closed exactly a hundred years later. The top photograph dates from 1950 and shows a well-maintained building and grounds, a sorry contrast to the scene three years after closure with the empty church being enveloped by the encroaching vegetation. Local people have many happy memories of St Peter's and in the lower photograph a smiling wedding party makes its way up the steep pathway on a snowy Saturday in March 1970.

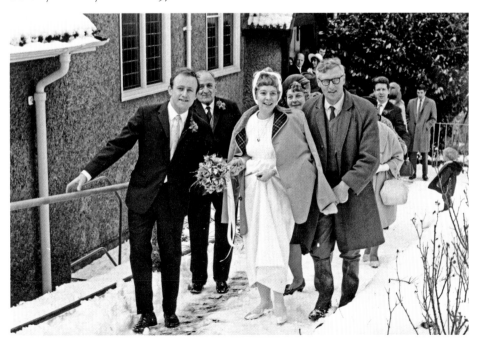

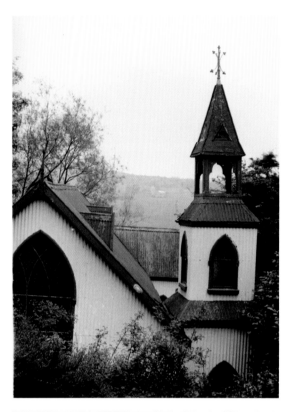

The Tin Tabernacle
An earlier church on Cleeve Hill
was known affectionately as the
Tin Tabernacle, being constructed
of corrugated iron in an attempt to
lighten the burden on its unstable
foundations. It opened in 1901 but its
structure became unsafe due to the
moving hillside and after a long period
of lying empty since 1972 it was finally
demolished in 1988, opening up the
vista of Nottingham Hill across the
valley, as seen in the lower picture.

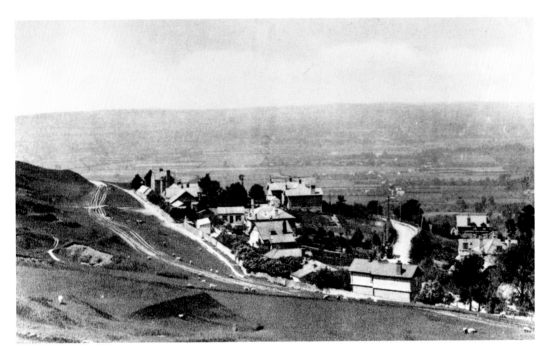

A View from the Common I

Here is another scene favoured by the makers of Edwardian postcards. It illustrates how the construction of the present main road in 1823 resulted in the development of the community early in the twentieth century in the pocket of land between this road and the original higher road. The latter route can be seen in the upper photograph cutting diagonally across the scene parallel to the boundaries of the various properties.

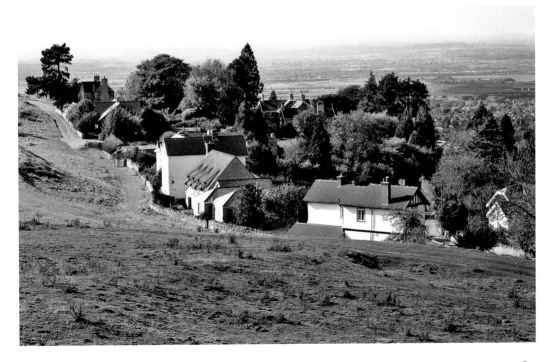

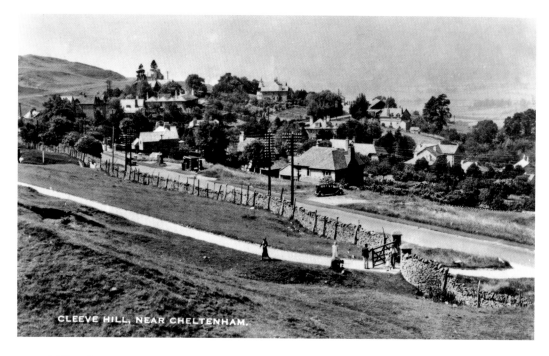

CLEEVE HILL, NEAR CHELTENHAM.

A View from the Common II

This classic postcard viewpoint, taken in the 1950s from the racing stables, shows the entrance to the common at the top of Stockwell Lane and some of the principal houses of the community of Cleeve Hill. Also in the picture stands the body of a Cheltenham tram car which was used for many years as a bus shelter for passengers wanting to travel on the replacement buses. Today there is barely a glimpse of any building through the burgeoning screen of greenery.

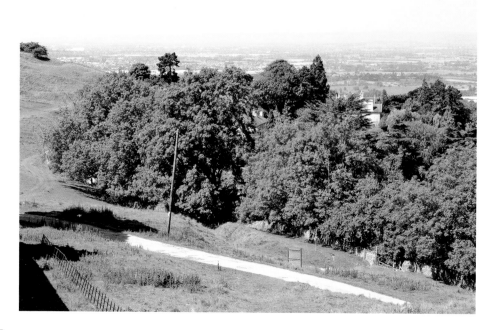

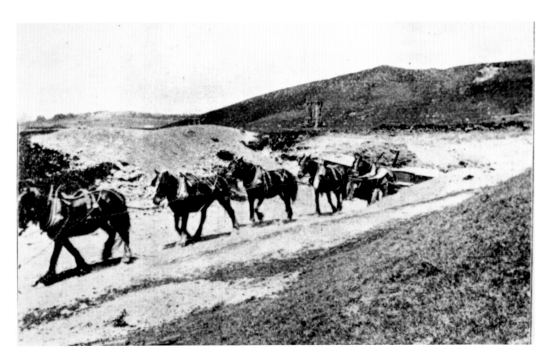

A Cleeve Hill Quarry

The top view is a rare photograph taken before the First World War of a heavy stone wagon being hauled out of Wickfield Quarry by a team of no less than five horses. Descending the hill with such a heavy load created many problems, for example the descent down Stockwell Lane was perilous, as the wagon slid on its way with its wheels locked onto iron skid-shoes over the unsurfaced ruts of the lane. Today the quarry presents a very different scene as a car park for visitors to the common.

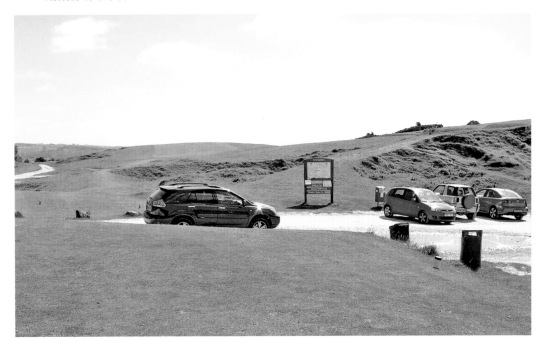

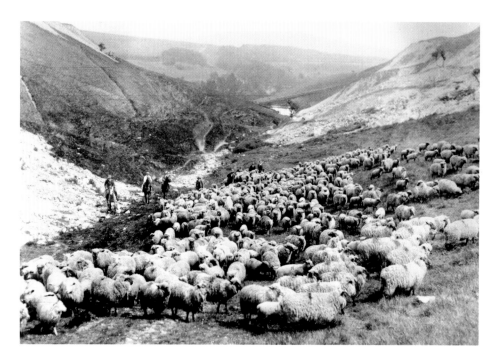

Watery Bottom, Cleeve Common

For over a thousand years sheep and cattle have grazed on Cleeve Common during the summer months. The upper photograph shows just how large such flocks could be. Walter Denley (on the extreme left) and his hands are driving the sheep up Watery Bottom in *c.* 1930. The infant River Isbourne rises here and at the end of the nineteenth century it was dammed to form The Washpool, seen in the middle distance, from where it fed a sheep-dipping trough, which featured in our first volume. The modern view indicates sheep are no longer dipped here; the landscape is deserted.

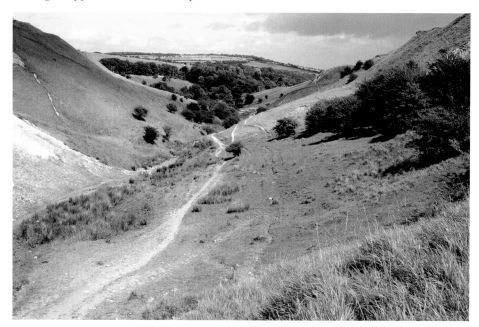

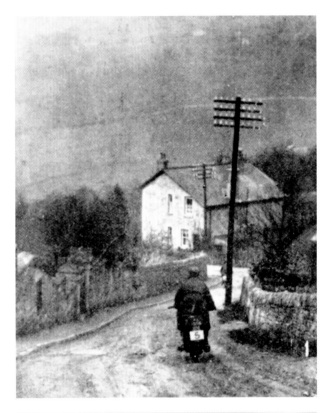

Post Office Lane

The rough unsurfaced lanes ascending the Cotswold scarp became popular in the early years of the twentieth century for motor trials, initially only motorcycles, but later motorcars. Here a lone motorcyclist cautiously descends Post Office Lane during the famous Colmore Trophy trials in February 1925. The dwelling on the corner lower down the hill is Denewood which housed the local post office and thus gave the lane its name. Just visible on the left is Glendale where local entrepreneur and builder of Post Office Lane, Arthur Yiend, lived.

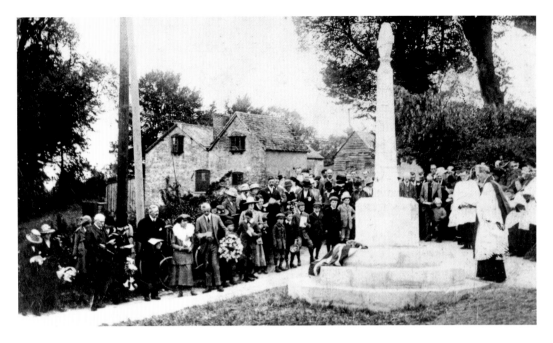

Southam War Memorial

We have been fortunate to find this photograph showing the unique event of the dedication of Southam war memorial by the rector of Bishop's Cleeve, Nigel Morgan-Brown. He arrived as rector in 1919 and this must have been one of his first public engagements. Here we also see the assembled company of villagers and church dignitaries gathered around the green for the ceremony. Today the memorial becomes a focus every November for the Royal British Legion's memorial service.

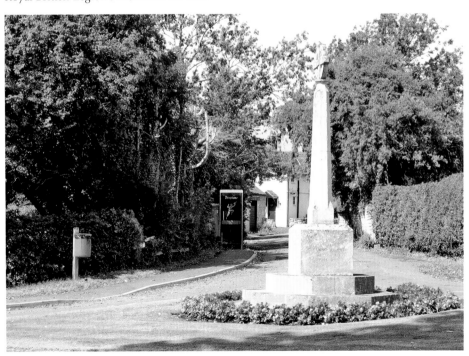

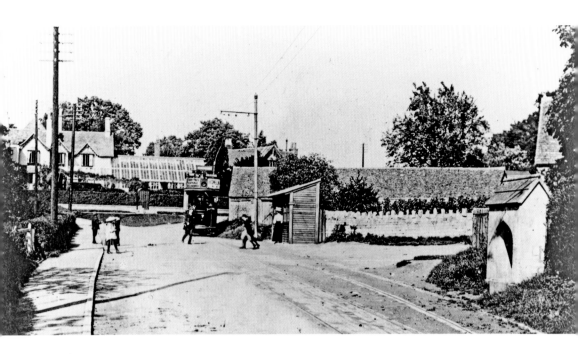

Southam Tram Stop

Here is another photograph of the Southam tram stop to complement the one in our first selection. The single-decker tramcar has made its way down Cleeve Hill to the stop outside Villar's Farm some time shortly after the line was opened in 1901. Here it will await the double-decker which will come from Cheltenham Lansdown railway station. Notice the small waiting room for passengers changing trams. Today cars have replaced the trams and the stone water cistern of 1846 is barely visible under a canopy of ivy.

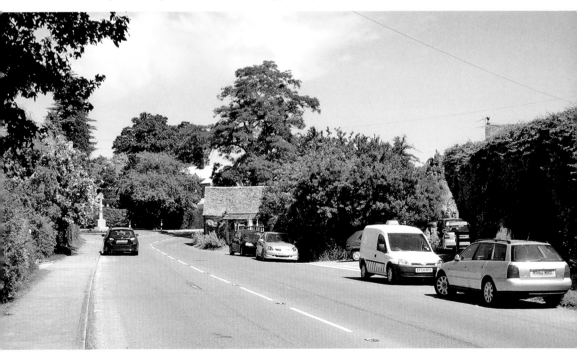

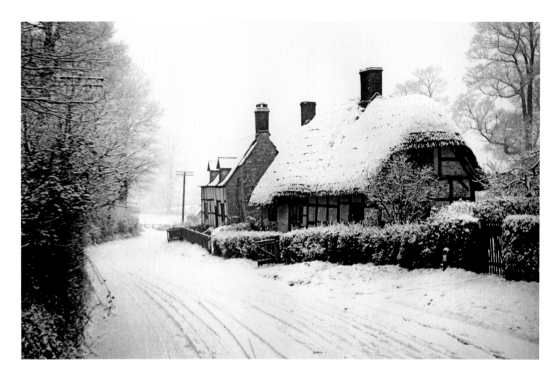

Southam Lane

These cottages were shown in our earlier volume. In this archetypal Christmas card scene they sit snugly under their snow-covered roofs whilst wheel tracks on the road outside mark the passing of horse-drawn traffic, perhaps the early morning milk float from nearby Manor Farm. Today the idyllic scene has vanished forever; its only reference being the line of the road snaking down through the village.

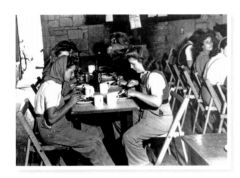

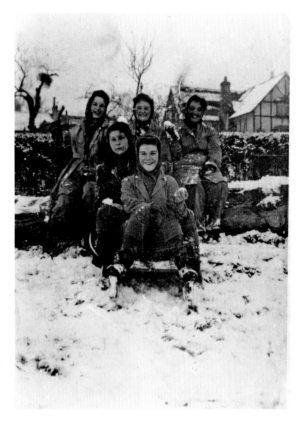

Women's Land Army

Between 1943 and 1946 Pigeon House provided billets for the Land Girls of the Second World War. Despite the gruelling toil on the local farms they had time to enjoy themselves in the snow, sustained by the hearty food provided in one of the buildings of the farm. Pigeon House might date back to the twelfth century but the timber framing was added as recently as 1924.

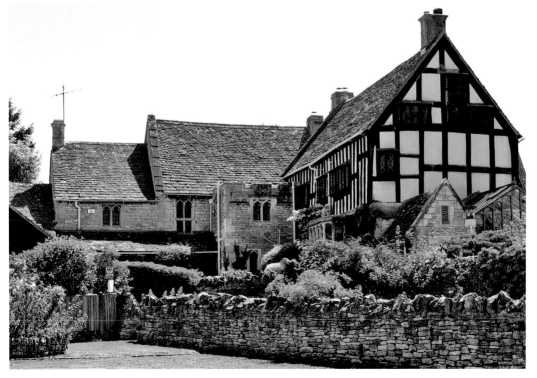

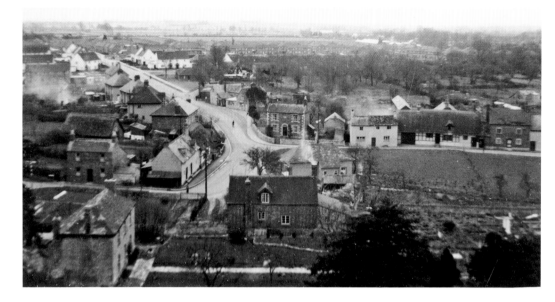

View from the Church Tower
We end our collection as we started it, with an 'aerial' view. This was taken from the tower in 1955 and carries much of interest. It shows the beginnings of Smiths' estate in the distance and the fields where it would spread. In the foreground are many of the buildings featured in our two collections: the Royal Oak public house, Edginton's bakery and the original arrangment of the junction of Pecked Lane and Church Road. We hope your understanding of such changes has been increased by this second selection of historic photographs.

Acknowledgements

Again the basis for this selection of photographs has been our own collections of photographs and postcards built up over many years. Nevertheless we are indebted to a number of people, this year as last year, who have lent us their photographs and/or given of their knowledge to help us with the captions. So we are grateful to Martin Coombes, the late Hugh Denham, Vera Gardner, Peter Lewis, the late Charles Minett, Margaret Minett, Julie Morgan, Geoff Pitt, Morgan Pearce, the late Bill Potter, Eunice Powell, Mollie Quilter, Trixie Reed, Peggy Stephens, Graham Teale (Archivist of Gotherington Local History Society), Mark Tsakarisianos and Susanne Weir. We are especially grateful to Mike Ralls and his wife Sheila who, over a twelve year period, built up a collection of historic photographs, many of which can be seen at www.imagesofbishopscleeve.info. We hope we have traced all copyright holders. Finally we again wish to acknowledge the constant support of our wives, Margaret and Loretta. Any faults remain, of course, our own.

David Aldred
Tim Curr